Hogarth's China

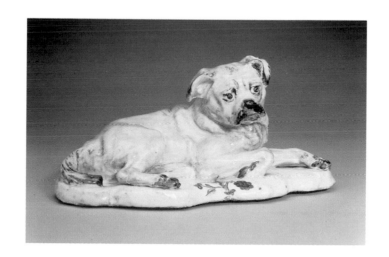

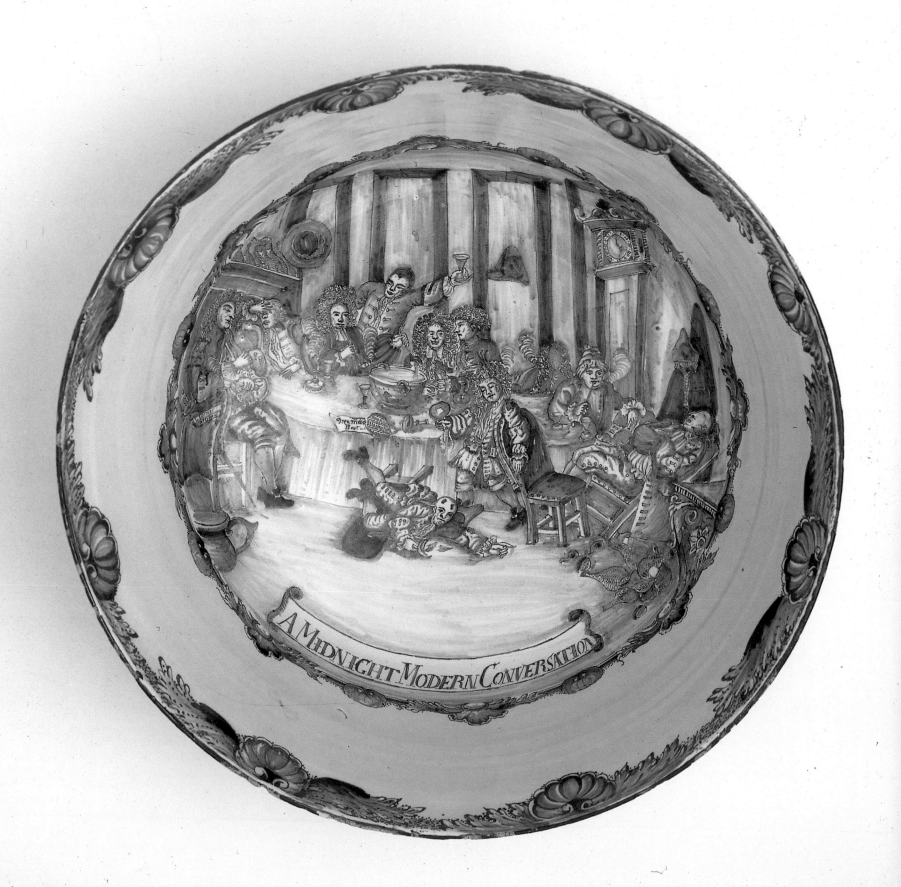

A MIDNIGHT MODERN CONVERSATION

Hogarth's China

HOGARTH'S PAINTINGS AND EIGHTEENTH-CENTURY CERAMICS

LARS THARP

MERRELL HOLBERTON
PUBLISHERS LONDON

First published in 1997 by
Merrell Holberton Publishers Ltd
Willcox House, 42 Southwark Street, London SE1 1UN

Text copyright © 1997 Lars Tharp

ISBN 1 85894 040 0

Produced by Merrell Holberton Publishers
Designed by Roger Davies

Printed and bound in Italy

Jacket illustration: William Hogarth, *Marriage à la Mode: The breakfast scene*, 1743–45,
National Gallery, London, inset over a mantelpiece in Burghley House, Lincolnshire
Back jacket illustration: *Wilkes*, Staffordshire pearlware figure, *ca.* 1770,
Royal Pavilion Art Gallery, Brighton
Frontispiece: English delftware punchbowl, dated 1748, with a dedication *Lawrence Har[ri]son 1748*,
Manchester City Art Galleries, Greg Bequest
Half title: *Trump*, Chelsea porcelain figure, *ca.* 1745–47, courtesy of Sotheby's, London

Contents

Sponsor's Foreword

In his final work, *The Bathos* (1764), William Hogarth (1697–1764) depicts a landscape about to be consumed by flames. Fire was, in fact, an ever-present hazard in Hogarth's world. He was thirty-nine years old when he became a client of the young Sun Fire Office, precursor of today's Royal & Sun Alliance Insurance (founded in 1711). The Sun's 1736 ledger entry reads:[1]

William Hogarth of the parish of St. Martin's in the Fields[,] painter. On his household goods and goods in trade and copper plates[,] pictures excepted[,] in a brick house being his now dwelling house [...] Not exceeding five hundred pound

The event which prompted our client to take out policies both for himself and for his sisters, Anne and Mary, was the death of their mother who, one year previously, had expired following the trauma of her escape from a fire in St Martin's Lane. Fire was a frequent visitor to all towns and cities: the London in which Hogarth grew up had itself risen from ashes following the disastrous Great Fire of September 1666. Burning four days on end the flames had destroyed the medieval city, claiming at its heart the Romanesque and Gothic cathedral of St Paul's.

The cathedral and city which rose in its place were largely the creation of Sir Christopher Wren (1632–1723) and his pupils. To prevent a recurrence of the disaster new building regulations were enacted – the use of brick, with slates or tiles for roofing, as well as a compulsory roof parapet. Such precautions notwithstanding, Sir Christopher was sufficiently prudent to insure himself against the very element which had, so to speak, lit his torch.[2] Indeed, the sight of fire brigades sallying forth from one of the handful of specialized insurers was commonplace throughout the eighteenth century and is depicted by Hogarth in his satirical print, *The Times* (1762).[3]

With their smouldering footlights, raucous clientele and altogether inflammatory atmosphere, London theatres were an insurer's nightmare. David Garrick (1717–1779), the greatest actor of his day and one of Hogarth's closest companions, took pains to insure his own Drury Lane Theatre.[4] Further upstream, on the south bank of the Thames, Jonathan Tyers's (1702–1767) Vauxhall Pleasure Gardens were a prime target for fire damage[5] – the walks, avenues and supper boxes each night festooned with colourful lights and lanterns illuminating the newly installed paintings of William Hogarth, Francis Hayman and other contemporaries.[6] Here one could enjoy open-air performances of England's greatest living composer, George Frederick Handel (1685–1759), in whose honour Tyers installed a specially commissioned marble statue by Louis François Roubiliac (1695–1762). Today Roubiliac's *Handel* (originally costing about £300) stands in the Victoria and Albert Museum, while his marble *Self-portrait* looks across its room in the National Portrait Gallery to another of his masterpieces, the terracotta portrait bust of his friend (and almost exact contemporary), William Hogarth. We know that Roubiliac and Thomas Chippendale claimed jointly on their own Sun policy following fire damage, again in St Martin's Lane,[7] while Roubiliac's friend the celebrated silversmith Nicholas Sprimont, owner manufacturer of one of London's very first porcelain enterprises, the newly established Chelsea China works, was himself insured with the Sun.[8]

Although, beyond the demise of his mother, we have no records of Hogarth suffering any personal injury or loss through fire, he must have mourned the destruction of his early series *A Harlot's Progress* (1730–32) when in 1755, nine years before his death, most or all six paintings from which the print series establishing his early reputation were

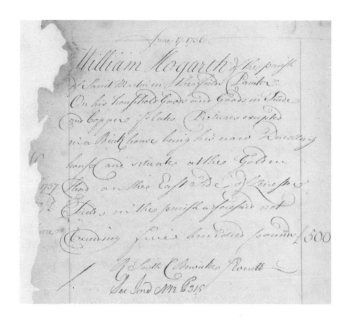

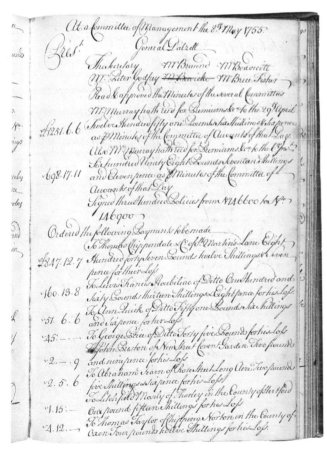

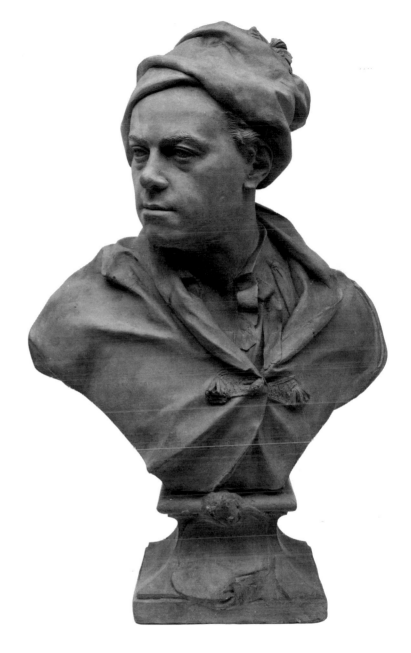

ABOVE LEFT Hogarth's Sun Fire Office insurance policy, 1736

ABOVE Louis François Roubiliac, *William Hogarth*, 1741, terracotta, National Portrait Gallery, London

LEFT Sun Fire Office ledger entry recording compensation payments to Louis François Roubiliac and Thomas Chippendale, 1755

engraved perished in a fire at Fonthill Abbey. [9]

In addition to the artists within and beyond Hogarth's own circle, the infant companies of today's Royal & SunAlliance also covered some of the greatest commercial ventures of the eighteenth century. Of these, none was more concerned with fire than the ceramics industry. As we shall see in the following pages, native English potters were driven into an unprecedented, ever intensifying competition, not only against Europeans and China but equally amongst themselves. The name to emerge above all others, influencing his own and the following centuries, was Josiah Wedgwood (1730–1795), colossus of the Industrial Revolution. His scientific approach to all aspects of his business – from manufacture to marketing – is epitomized by his invention of the ceramic pyrometer, for the first time giving the potter precise temperature control of kiln firing and replacing the sometimes haphazard skill of the kiln master by an industrial tool. Two hundred years later, in that same spirit of science and experiment, man turns once more to ceramic innovation, using tiles – his native earth – to shield his spacecraft from the effects of heat.

In our sponsorship of *Hogarth's China* we pay tribute to the genius of Hogarth, to his age and to his successors. From the eighteenth century to the present, as insurers of individuals, of leading cultural institutions and of businesses – not least the ceramic industry in all its guises from fine china to advanced electronic applications on earth and in space – the Royal & SunAlliance continues in its support of Art and Industry.

1 Sun Fire Office, policy number 70649, 17 June 1736. We are particularly indebted to professor Ronald Paulson for uncovering Hogarth's policy (see Paulson 1992, II, p. 53f.), and are thankful to Lars Tharp for rekindling this association on the occasion of Hogarth's 1997 tercentenary.

2 Sun Fire Office policy numbers 20324 and 20325 (6 December 1720).

3 There are reports of Mutual Fire Insurance Clubs being set up as early as 1667 although the first single company was Barbon's Fire Office in 1680. Barbon's company had a brigade in 1681 and most of the later companies had fire brigades in operation very shortly after they opened for business. The London fire brigades were formed into a public service brigade in 1865, substantially anticipated by the Edinburgh Brigades which went public in 1824.

4 Sun Fire Office policy number 333843 (David Garrick and James Lacy, 1773).

5 By the end of the eighteenth century the Vauxhall Pleasure Gardens were insured with the Sun for £20,800; at about the same time Drury Lane Theatre was insured for £10,000.

6 See David Coke, 'Vauxhall Gardens', in *Rococo* 1984.

7 The Sun's register records Roubiliac's insurance policy for 1746/47 as well as a later (?) claim entered jointly with none other than Thomas Chippendale, both of whom suffered some loss at a common St Martin's Lane address.

8 Elizabeth Adams, 'Nicholas Sprimont's Business Premises', *English Ceramics Circle Transactions*, vol. 13, pt. 1, 1987

9 The series was very largely inspired by 'A Defense of Prostitutes', *The Spectator*, no. 266, 1711/12, by Sir Richard Steele, another Sun client.

ROYAL & SUNALLIANCE

Roger Taylor
Executive Deputy Chairman

RIGHT William Hogarth, *Tailpiece*, or *The Bathos*, April 1764, engraving, The Whitworth Art Gallery, Manchester

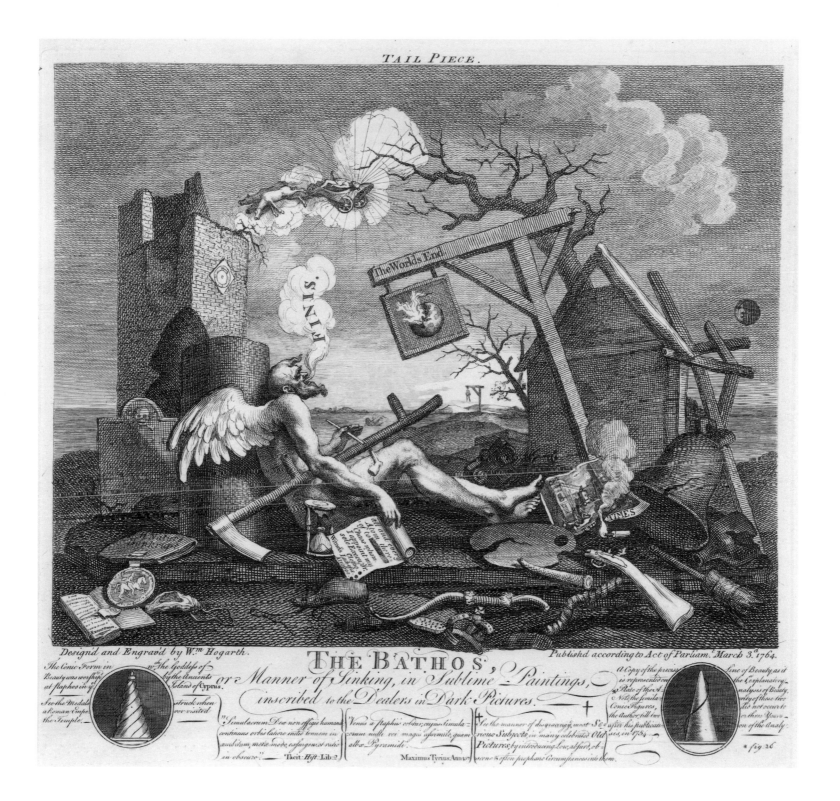

FINIS.

The World's End

Design'd and Engrav'd by W.ᵐ Hogarth.

Publish'd according to Act of Parliam. March 3.ᵈ 1764.

THE BATHOS,
or Manner of Sinking, in Sublime Paintings,
inscribed to the Dealers in Dark Pictures. ✝

9

Acknowledgements

The idea of combining Hogarth's prints and paintings with ceramics of the period first emerged about a dozen years ago while I was working at Sotheby's. In the intervening years leading to the present book I have received help and encouragement from many colleagues, friends and enthusiasts both of ceramics and of Hogarth. To list them all would now be impossible, but my especial thanks go to Pat Halfpenny and Gaye Blake Roberts who, after my talk to The Associates of Wedgwood marking the bicentenial of Josiah Wedgwood's death (1995), approached me and suggested that the general theme would lend itself to an exhibition. The result has been *China in Hogarth's England*, a selection of ceramics and associated prints exhibited on the tercentenary of his birth within the 1997 International Ceramics Fair and Seminar in London. I thank Brian and Anna Haughton as well as their team for their help and enthusiasm in putting on the show. In addition to these prime movers I also thank Stella Beddoe (Royal Pavilion Museums and Art Gallery, Brighton), Rhian Harris (Thomas Coram Foundation) and Barley Roscoe (Holburne Museum, Bath) for their encouragement and valuable advice.

In securing the support and sponsorship of William Hogarth's original insurers (The Sun Fire Office) I am indebted to the enthusiasm of Martin Booth and all his colleagues at today's Royal & SunAlliance Insurance Company. I am also beholden to Professor Ronald Paulson for a particular footnote in his latest three-volume work which prompted us to rekindle this venerable Sun association.

My publishers, Hugh Merrell and Paul Holberton have been excellent working partners at a very busy time and I am particularly indebted to the flair of Annabel Taylor for her incisive revisions of text and the overall plan in a highly tangential work.

Finally, I dedicate the whole enterprise to my family: to my parents for their unwitting surrender of a book on Hogarth which I originally gave to them some years ago; and above all to my wife and daughters for living so patiently with the sometimes testy presence of the Great Man. By now they will be aware that, far from exorcising him, their encouragement and help have only served to make William Hogarth a welcome and regular visitor to our household for years to come.

The exhibition and the present book have brought together objects from a diverse group of private and institutional owners. In addition to those generous lenders who prefer to remain anonymous, I would like to thank:

Aberdeen City Museum & Art Gallery; Garry Atkins; Royal Pavilion Art Gallery and Museums, Brighton; Jon Culverhouse and the Trustees of the Burghley Estate, Stamford, Lincolnshire; Hugo Morely Fletcher, Colin Sheaf, Paul Tippett and Jodie Wilkie, Christie's, London and New York; David Coke; The Thomas Coram Foundation; Meredith Chilton, Gardner Museum, Toronto; Dr David Hopkins, University of Bristol; Jonathan Horne; David Howard; Raymond Lane; Mr and Mrs Tom Odling; David Hill, Archivist, Royal & SunAlliance Insurance; Anne Pollen, Tish Roberts and Diane MacWaters, Sotheby's, London and New York; The staff and partners of Messrs Robert Shaw, Guildford; The Metalwork, European Ceramics and Far Eastern Departments at the Victoria and Albert Museum, London; The Trustees of the Wedgwood Museum; Hugh Weldon; The Whitworth Art Gallery, Manchester; Lavinia Wilson; Raymond Yarbrough.

Photographic Acknowledgements

Ken Adlard; Birmingham Museums & Art Gallery; Britannia Antiques, London; British Museum, London; Christie's, London and New York; Brian Haughton Antiques, London; Manchester City Art Galleries; Museum of London; The National Gallery, London; National Museum and Art Gallery, Cardiff; The National Portrait Gallery, London; Philadelphia Museum of Art: The John H. McFadden Collection; Punch Ltd., London; Rijksmuseum, Amsterdam; Nicholas Sinclair; The Trustees of Sir John Soane's Museum, London; Sotheby's, London and New York; Tate Gallery, London; The Board and Trustees of the Victoria and Albert Museum, London; The Trustees of The Wedgwood Museum, Barlaston, Stoke-on-Trent, Staffordshire, England; The Whitworth Art Gallery, The University of Manchester; The Witt Library, London.

RIGHT Detail of fig. 70, p. 82

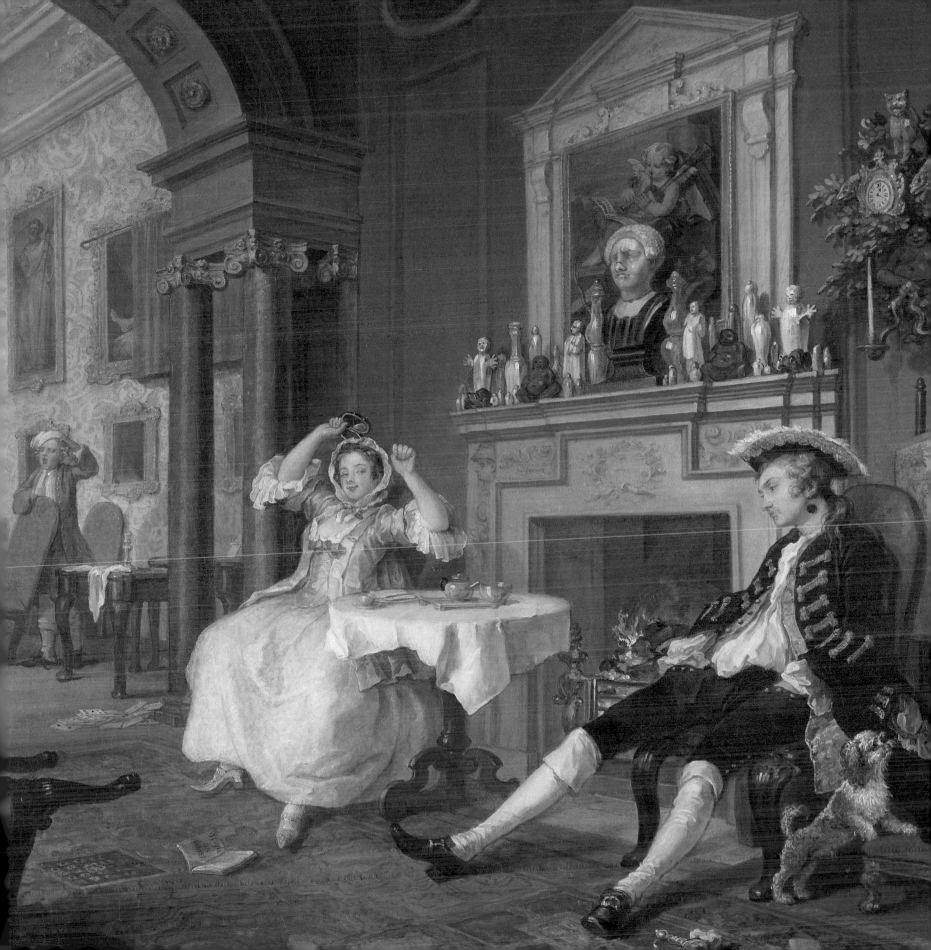

Introduction

One afternoon, while passing time in the National Gallery, London, I found myself standing before the second painting in Hogarth's six-part series *Marriage à la Mode* (1743–45). A familiar scene, I thought, but suddenly something was wrong. Here, in a classic stately-home interior, the young inhabitants were seated on either side of a table garnished with tea wares, in front of a mantelpiece crammed with objects which corresponded to nothing I had ever seen. Among the clutter of large, small and miniature vases, little brown Buddhas and green oriental toads, were several white human figures, some standing with outstretched, oversized hands. They appeared to be made of porcelain. The more I looked, the more incongruous they seemed. Why, having created such a credible room inhabited by two such believable people – she flushed, he exhausted after the rigours of the evening – should Hogarth disrupt this reality with a background arrangement of intrusive, nonsensical knick-knacks? He had, after all, plenty of real artefacts from which to choose. My curiosity awakened, I decided to find out more about Hogarth and to look for other examples of ceramic imagery.

By chance, I had recently been giving introductory talks on pottery and porcelain, and in order to inject some colour and background into the subject I had been on the look-out for seventeenth- or eighteenth-century illustrations showing ceramics in everyday use. Could Hogarth be my answer? He had lived through a crucial period of English political, economic, artistic – and ceramic – history. From the 1720s to the 1760s, the period in which Hogarth was painting, the native English potter's world was turned inside out, culminating in the creation of English porcelain and the emergence of Josiah Wedgwood. By looking closely at Hogarth's works could one actually follow this transformation?

And so began *Hogarth's China*.

As my list of Hogarth's 'ceramic snapshots' grew, it became apparent that by bringing together and comparing ceramic specimens of the period with the pictures in which their counterparts were depicted one could accomplish two things simultaneously.

Firstly, it was possible to create a skeletal summary of all the various English ceramic traditions as they evolved from the seventeenth into the eighteenth century: the native lead-glazed earthenwares stretching back to medieval times; the coarse brown stonewares emanating from the German tradition; the tin-glazed earthenwares – so called 'delftwares' – with their Dutch and, ultimately, Italian origins; the experiments in fine red stoneware, stimulated by the imports of Chinese tea wares from Yixing; the salt-glazed fine white stonewares imitating porcelain in exceptional thinness and whiteness, but not translucency; and finally 'china', or rather porcelain, whether the real thing produced in China itself, or produced in Europe or one of the many English factories which sprang up in London and beyond from the 1740s onwards as a direct response to imports from China and Continental Europe.[1]

Secondly, having identified the main ceramic groupings of the period, one could then begin to track their context, building up a picture of their respective rôles and status. In fact, by using Hogarth's own 'sets', arranged in chronological order from the 1720s to the 1760s, we are able to move through the vast theatre of London life, from high to low, forming a picture of fashion as well as catching glimpses of an industry in transformation. Passing from the Baroque, through the Rococo and on towards the Neoclassical, a span roughly corresponding to Hogarth's own career, we can look further into the late eighteenth century and on into the nine-

William Hogarth, *The Distressed Poet*, March 1736/37, Birmingham Museums and Art Gallery

teenth, a period which saw the consolidation of England's ceramic traditions.

In addition to these two objectives a third and unexpected dimension began to emerge. With their appearance on punchbowls, sprigged on to mugs and printed on to dishes, it became clear that Hogarth's own popular compositions were themselves bought and copied by the ceramic designer. So, despite his very clear lampooning (see *Taste in High Life*, fig. 79, p. 92) of the china enthusiasts – the eighteenth-century dilettanti whose late nineteenth-century counterparts were dubbed 'china maniacs' – he had himself become an unwitting source for ceramic designers both at home and abroad, from the eighteenth and into the nineteenth century.

One example is Hogarth's faithful dog Trump, who figures in his well known self-portrait (fig. 1, p. 16). The source was Louis François Roubiliac, who, one may imagine, made simultaneous observational notes of his sitter's dog, lying at his master's feet, while sculpting the magnificent terracotta bust of Hogarth (see p. 7). Somehow a copy of Roubiliac's terracotta original, executed in 1741, had been acquired by the new Chelsea factory whose founding proprietor, Nicholas Sprimont – fellow Huguenot, distinguished silversmith and godfather to Roubiliac's daughter, Sophie – produced a number of coloured and uncoloured Trumps in the early 1750s (see figs. 3 and 5, pp. 17 and 19). Was Hogarth ever aware that a much loved member of his very own household had become a model for 'china' – the same faddish material lashed by his satirical brush?

It was inevitable that, in recording the riotous world about him, Hogarth's own popular prints offered a natural design source for potters both at home and abroad. Of his two hundred and fifty or so printed images at least a dozen have been transposed into clay, sometimes in part (for example, *A Harlot's Progress II*, see fig. 25, p. 41) and sometimes *in toto* (for example, *A Midnight Modern Conversation*, see figs. 35 and 36, pp. 50 and 51). From Staffordshire to Delft, from Meissen to Canton, as we shall see in the following pages, Hogarth's own two-dimensional images participated three-dimensionally in the world he depicted.

If the warp of Hogarth's canvas is straightforward journalism, the faithful depiction of real persons and events, his weft is moral comment. To achieve in pictures what Charles Dickens was later to accomplish in words[2] – a 360° panorama of people and situations intermingled with the author's judgement – Hogarth invented a new pictorial genre, reflecting the literary age in which he lived. Driven beyond the confines of the single narrative painting he created the visual epic, a narrative series of four, six or eight paintings, tracing the rise and fall (the ironically titled 'progress') of a hero or heroine,[3] each picture analogous to each of the *cantos* which make up Alexander Pope's mock-heroic poems *The Rape of the Lock* and *The Dunciad*.[4] The term he coined for this form was the 'Modern Moral Subject'. By successfully lobbying for a Copyright Act (1736) he protected the reproduction rights of his own images, and by converting them into highly popular print series created his own fortune, allowing him to escape from the traditional bonds of aristocratic patronage which until then had defined and restricted the scope of an artist's genius. His images disseminated throughout the kingdom and abroad; Hogarth could paint, draw and print what he liked.

Like Dickens's own works, published in instalments one hundred years later, prints of Hogarth's four great series – *A Harlot's Progress* (1732), *The Rake's Progress* (1735), *Marriage à la Mode* (1745) and *An Election* (1755–58) – were eagerly snapped up the moment they appeared. Just as Pope's poems were published with the author's own running commentary and footnotes (keeping the reader at all times aware of the author's subtle, not to say obscure, allusions), Hogarth, too, punctuates his prints and paintings with symbols designed to guide the 'reader' into a deeper understanding of the action. With his own highly honed theories on composition concerned with 'leading the eye' along a system of inner curves,

the same serpentine line depicted on the palette of his self-portrait (fig. 1, p. 16),[5] we may be sure that very few objects in any of Hogarth's moral works, however inadvertent or trivial they may seem, are there by chance.

Ceramics – by which term we embrace all utensils and ornaments made of clay, stoneware, earthenware or 'china' (or porcelain) – constitute only one of the many elements of furniture and decorations with which Hogarth completes his images. In his earlier portraits and gatherings of polite society, ceramics unavoidably feature centre stage as an integral part of the English tea ceremony (for example *Assembly at Wanstead House*, fig. 10, p. 23) or at the heart of a fashionable punch party (*A Midnight Modern Conversation*, fig. 32, p. 46). These pictures are themselves vivid and fascinating illustrations of customs which have changed beyond all recognition.

Meanwhile, in the moral series as well as in individual narrative compositions, Hogarth inserts ceramics for a particular joke (for example, the imminent destruction of a china stall in *Southwark Fair*, fig. 41, p. 56), or for pointed moral comment – nowhere more so than in the *Marriage* mantelpiece already mentioned (fig. 70, p. 82).

Finally, throughout the entire œuvre crockery simply features as unspecific clutter – in particular the first in the *Election* series, *An election entertainment* (fig. 88, p. 103) – or is that floating punchbowl an allegory for 'a ship at sea' …?

By bringing together all these strands, preceded by a broad review of the basic ceramic traditions and their place in Georgian society, I have endeavoured to paint a portrait of an age of ceramic revolutions as captured by the critical eye of William Hogarth. It is a rich heritage which, thanks to many of the very collectors he might have ridiculed, to this day surrounds us in our museums and shops, at public auctions and at fairs.

Before returning to those falling tea wares … and to those mantelpiece ornaments … let us look at William Hogarth, man and artist.

Hogarth's China

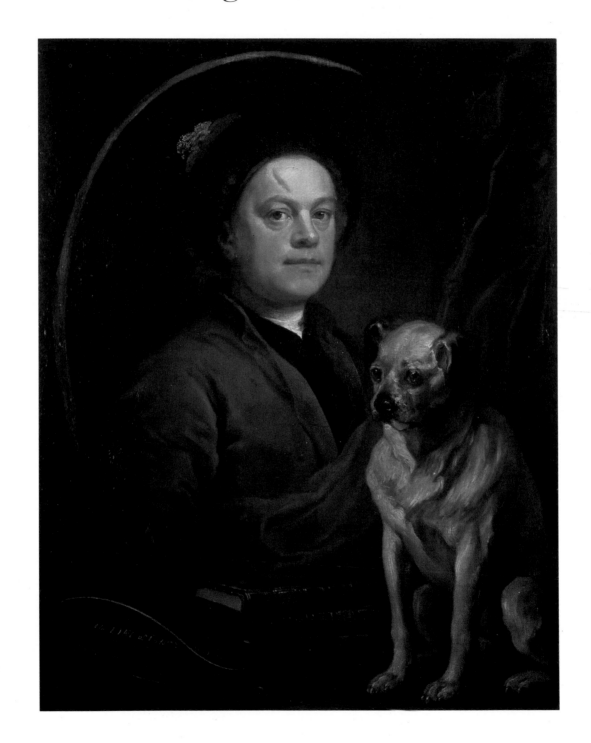

William Hogarth lived through a period of English history which saw the slow but certain drift of power away from absolute monarchy towards parliamentary democracy; a period which brought the resolution of the old and disruptive Catholic–Protestant divide, and a period in which the seeds of Empire were taking root, forming a market for an imminent Industrial Revolution. After the ravages of civil war, it was a time of restoration, of prolonged internal stability giving rise to prosperity and a whole new class whose wealth was based on business, not on inherited land. Hogarth's own family, originating in North Country yeoman stock, had come to London to be part of the rising bourgeoisie of professional and literary classes. But Richard Hogarth's all Latin-speaking coffee-house venture had failed, bringing him within the confines of the Fleet Prison for insolvent debtors. Far from finding the streets paved with gold, his son, the young William, found himself apprenticed into the drudgery of the silver-engraving trade. Driven by a native artistic instinct and a natural talent for drawing which brought him to the door of Sir James Thornhill (1675–1734), Serjeant Painter to the King, he abandoned his apprenticeship and thereby forfeited the potentially useful protection of a guild.[1] If rash, his instincts and ambition were more than fulfilled. Within a few years not only had he married the skills of engraving with those of painting, uniquely empowering him to issue printed versions of the images for which he clearly had a talent, he had also married Sir James's daughter.

With political consolidation moving hand in hand with a reconstructed London came new markets and new institutions: the coffee-houses became the nuclei of information

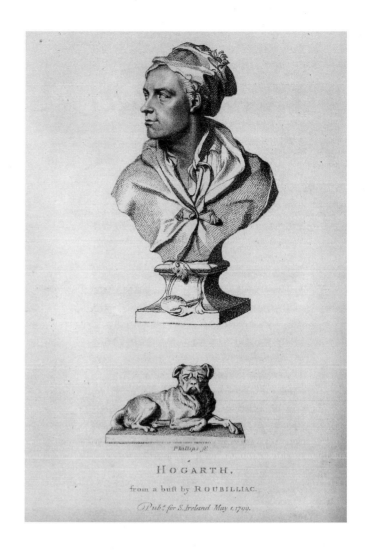

LEFT Fig. 1 William Hogarth, *Self-portrait with pug*, 1745, Tate Gallery, London
ABOVE Fig. 2 Samuel Ireland, *Graphic Illustrations of Hogarth*, 1799, II, Frontispiece, The Whitworth Art Gallery, Manchester
BELOW RIGHT Fig. 3 *Trump*, Chelsea porcelain figure, *ca.* 1750, courtesy of Sotheby's, London

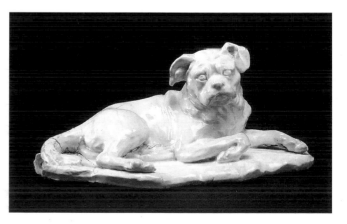

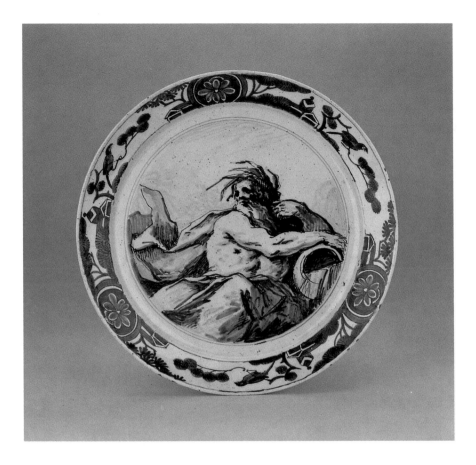

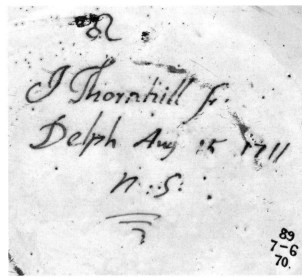

LEFT Fig. 4 Delftware zodiac plate, *Leo*, decorated by Sir James Thornhill, *ca.* 1711, British Museum, London

ABOVE Signature detail from underside of fig. 4

exchange with the birth of formal insurance (for example, Lloyd's coffee-house), of public auctions (Garraway's), of learning (the Royal Society, based on regular meetings at the Grecian, Threadneedle Street), and of simple club convenience (White's and Boodle's). Just as in the previous generation John Dryden's circle had met at the Great Coffee-House in Covent Garden (forming what was to be the literary element of Hogarth's very literary visual imagination), so it was at Slaughter's Coffee-House that Hogarth's own group of artists formed the kernel of the St Martin's Lane Academy (precursor of the Royal Academy) and of the group of artists involved with the Foundling Hospital. And though it was on the works of Shakespeare, Milton and Swift that Hogarth rested his *trompe l'œil* self-

portrait (see fig. 1, p. 16), throughout his life he was close to the literary and theatrical avantgarde: Henry Fielding, father of the English novel, David Garrick, master of the London stage. This cultural explosion was further reflected in the introduction of domestic furnishings and refinement never hitherto seen: in addition to their Grand Tour trophies people were compelled to keep up with all the latest turns in the many arts. Interiors filled out with clutter on a scale never seen in seventeenth-century England.

With all its new cogs, levers and wheels, such a society demanded frequent and copious lubrication. In addition to the increasing consumption of wine, punch and other forms of alcohol, the trading of coffee, chocolate and above all tea provided households with an exotic commodity

offering a suitable focus and ritual.

The East India Trade boomed, and with it, oriental porcelain. From the late seventeenth century onwards, from Hampton Court to Burghley House and beyond,[2] imported Chinese and Japanese 'china' crowded the well appointed mantelpiece. While this certainly stimulated the native tin-glazed and lead-glazed traditions, it was also a threat. Until the first production of English porcelain in the 1740s the English delftware industry held its own; Sir James Thornhill even painted a set of delftware plates representing the signs of the Zodiac (see fig. 4, opposite), while in the punchbowl traditionally associated with William Hogarth at today's Coram Foundation (fig. 34, p. 49) we see the potter's unabashed use of a Chinese porcelain design. When, in the 1740s, factories such as Bow and Chelsea finally began production, very many of the designs (such as the Bow jug, fig. 33, p. 48) were lifted straight from Chinese and Japanese forerunners as well as from the delftware reper-

Fig. 5 *Trump*, pair of Chelsea porcelain models, 1745/50, courtesy of Christie's, London

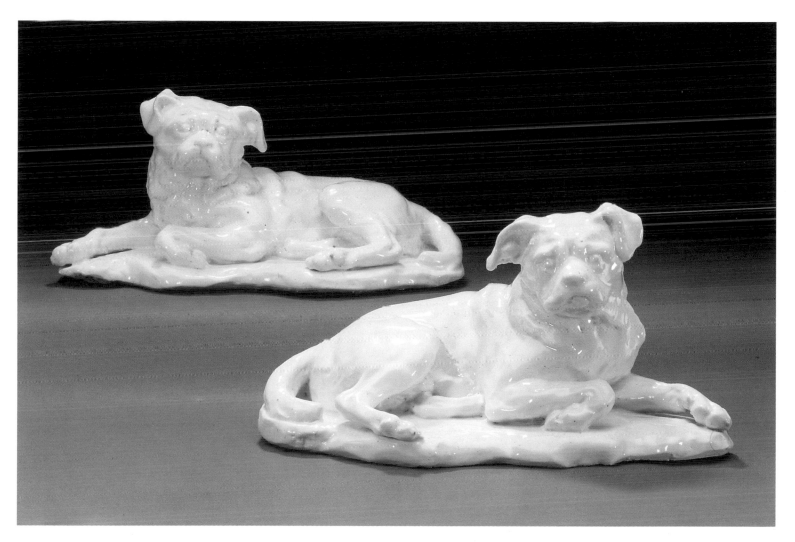

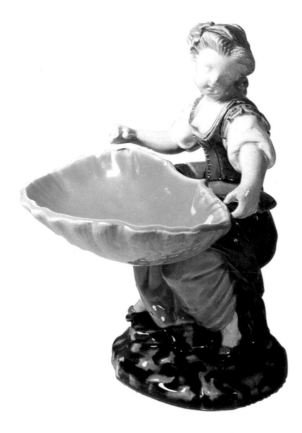

Fig. 6 'Hogarth Matchgirl', Minton majolica ware, 1873, courtesy of Britannia Antiques.

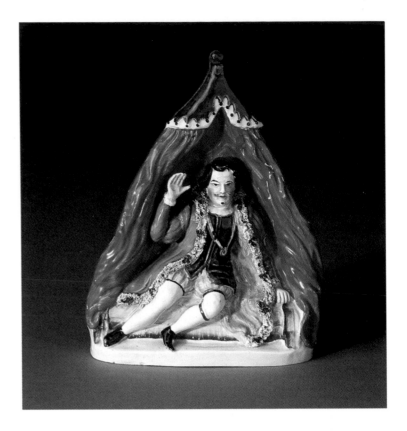

Fig. 7 *Garrick as Richard III*, Staffordshire earthenware flatback figure, mid-nineteenth-century, Royal Pavilion Art Gallery, Brighton

toire. With the separate maturing of the white stoneware into the creamware tradition (also in the 1740s) the delft-wares were dealt a deadly double blow.

If not his central concern, ceramics are a highly visible part of Hogarth's material world, many of the ceramic battles being waged, won and lost within Hogarth's own lifetime. Some of the major figures in those battles – Frye at Bow and Sprimont at Chelsea – were themselves closely associated with the tightly knit community of artists, theatre folk and writers of whom Hogarth was one.[3] They would certainly have rubbed shoulders. Thus by looking closely at the detail of his paintings and engravings we are given glimpses of a whole range of ceramics throughout the second quarter of the eighteenth century, not only the

materials (often difficult to identify) but also their context.

At the same time some of Hogarth's own images, especially those concerned with food and drink, were among the many sources of inspiration for the potter throughout the eighteenth century, whether in Staffordshire, Meissen, Delft or three thousand miles away in Canton. In some instances the translation of the image is direct and unmistakeable, in others it is only partial (perhaps via an intermediary source), while in yet others an apparent likeness may be purely misleading, a coincidence of pose.

In the case of the Berlin porcelain factory a number of punchbowls were made bearing an almost random selection of images taken from the Hogarth canon. It is interesting to note that even in the mid nineteenth century such

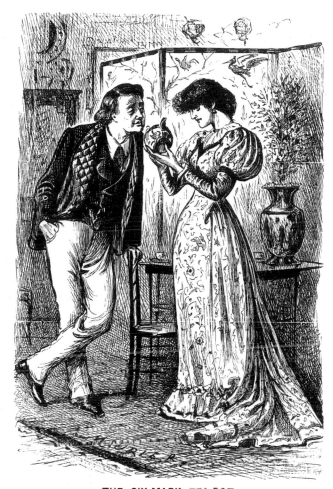

THE SIX-MARK TEA-POT.

Æsthetic Bridegroom. "IT IS QUITE CONSUMMATE, IS IT NOT?"
Intense Bride. "IT IS, INDEED! OH, ALGERNON, LET US LIVE UP TO IT!"

Fig. 8 George Du Maurier, *The Six-Mark Teapot*, published in *Punch*, May 1880, The Punch Archives

pieces were being produced, as indicated in the Berlin factory's catalogue for the Great Exhibition of 1851. Were they simply catering for the English market or was there even at this time a German following? What we do observe in this period is the sanitization of what Hogarth's contemporaries would have called 'low life'. Note how the little boy relieving himself before the dumbstruck girl in *The*

Enraged Musician (fig. 65, p. 78) is expurgated from the Berlin bowl (fig. 68, p. 80).

In England the ceramic revolution proceeded apace with the arrival of Josiah Wedgwood – a giant not only of the ceramic world but of the Industrial Revolution at large. In terms of style Wedgwood was a Neoclassicist: Rococo – with its infinite variety of curved and serpentine lines, of which Hogarth had been the high priest[4] – was in rapid decline, giving way to the straight lines and mirror symmetry of foreign Neoclassicism. In Hogarth's eyes with the worship of all things Italian the Universal Dullness described by Pope in *The Dunciad* had come to pass, as depicted in his valedictory print *The Bathos* (p. 9).

And yet, among the numerous Roman medallions, Greek urns, classical busts, cameos and intaglios executed in Wedgwood's bronze-like 'black basaltes' clay we see a pair of black dogs instantly recognizable as Trump, entered in the 1774 catalogue as "A Pug Dog",[5] and referred to in a later Wedgwood auction catalogue as "a pair of pug dogs, from a favourite dog of Hogarth's" (see fig. 103, p. 114). Their source was clearly one of the Roubiliac casts, supplied to them for 10s. 6d. from the stock of the late sculptor (Roubiliac predeceased his friend Hogarth by two years). As we have noted (see also figs. 3 and 5, pp. 17 and 19), these had earlier been used by the Chelsea factory.

Later in the mid nineteenth century the producers of Staffordshire flatback figures turned for inspiration to Hogarth's tent image of Garrick as Richard III (see figs. 7 and 81, opposite and p. 95). This must have been more as a tribute to Shakespeare and to the wicked old Plantagenet uncle than to either Hogarth or Garrick, both of whom had long since made their exits.

By the 1860s Britain was in the grip of 'china mania' – a china-hunting pack of enthusiasts headed by Lady Charlotte Schreiber rampaged through the *brocantes* and antiquity shops of Europe. Oscar Wilde's famous hyperbole "I find it harder and harder each day to live up to my blue

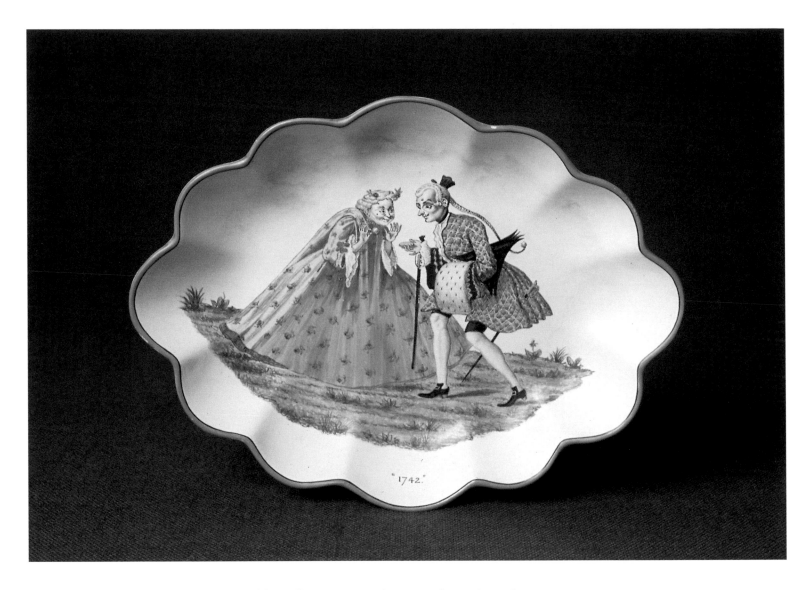

Fig. 9 Wedgwood creamware plate decorated by William James Goode, 1864, The Wedgwood Museum

china",[6] though uttered in jest (in 1874 while still an undergraduate at Oxford), epitomized a group of collectors relentlessly ridiculed by *Punch* in the needle-sharp engravings of George Du Maurier. His cartoon *The Six-Mark Teapot* (fig. 8, previous page) uncannily recalls the unauthorized print of Hogarth's *Taste in High Life* (fig. 79, p. 92), a detail of which was also 'lifted' into a Wedgwood dish dated 1864 (see fig. 9, above). Hogarth's and Du Maurier's

lampooning of the fashionable mantelpiece strikes at the sanctum of the china lover's temple.

By including the whole spectrum of Hogarth-on-to-pottery instances – from certain to probably coincidental, from the eighteenth- to a few nineteenth-century examples – we have sought to introduce the reader to a number of interesting issues while painting a ceramic portrait of an age as seen through Hogarth's eyes: a Porcelain's Progress.

Coffee, Tea and Chocolate

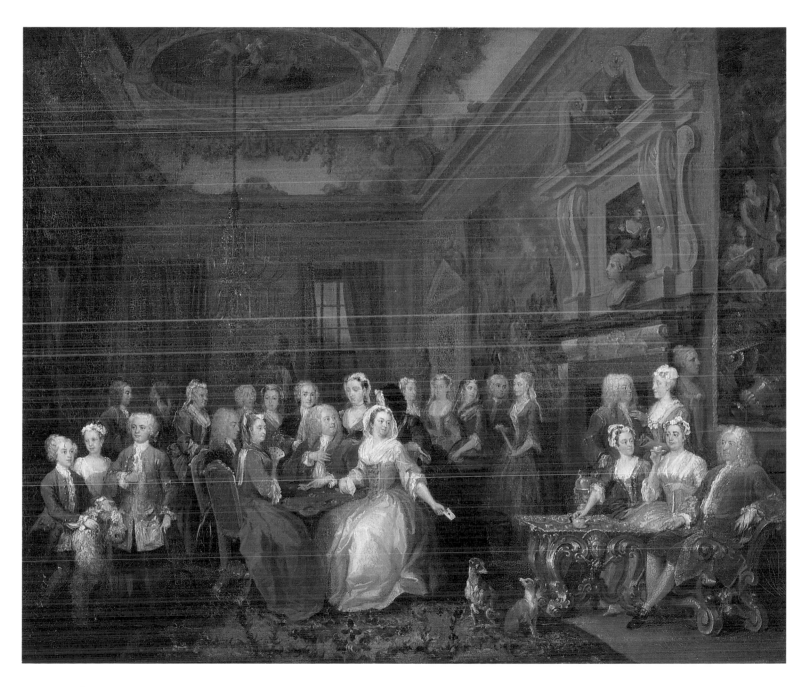

Fig. 10 William Hogarth, *Assembly at Wanstead House*, 1728–31, Philadelphia Museum of Art

parade of visions, including courtiers strutting in foppish 'teapot' pose.

In *Royalty, Episcopacy and the Law* (fig. 14, p. 27) Hogarth uses an astronomical event, the recent eclipse of the moon, as an oppurtunity to satirize three main bastions of the establishment. Following the literary examples of Pope's 'Cave of Spleen' and Jonathan Swift's *Tale of a Tub*, he presents them as 'not of this world', out of touch with reality and surrounded by 'teapot' courtiers (see bottom right of print).

A possible echo of Pope's poem, this is perhaps the earliest graphic use of the teapot as a metaphor for a fashion-conscious 'air-head'. In a reference to the vanity of tea-drinking society Hogarth ridicules the extreme elements of a class upon whom he initially depended for patronage.

Most eighteenth-century tea trays are silver, and very few delftware tea trays of the type shown in fig. 17 (previous page) have come down to us – being wide and flat they were difficult to make and fire, and are easily broken. The wares carried by the tray would almost certainly have been of porcelain or silver (or a combination) since tin-glazed earthenware, with its easily flaked or chipped, skin-like surface, has very poor tolerance of hot liquids.

The conversation piece painted in the centre echoes many of the elements in Hogarth's *The Strode Family* (fig. 19, p. 33): a tea-table gathering of a gentleman and two ladies, one of whom pulls up a chair as a pug looks on. The table is covered with a cloth and the wares are elevated on a tray – exactly as the tray on which the scene itself appears. Note also the presence of the turbaned black boy servant – a popular fashion accessory referred to in *A Harlot's Progress* (fig. 21, p. 35) and *Marriage à la Mode* (fig. 75, p. 88).[7]

The Staffordshire group in fig. 18 is a conversation piece in the round: as if all the figures depicted in the delftware tea tray (fig. 17, p. 29) had pulled up their chairs, here we see another foursome party, complete with a black servant (but excluding the pug), settling down to a tea table decked with the complete equipage of teapot, canister, slop basin, covered sugar bowl, tea bowls and saucers. One lady, having turned over her bowl, is either declining further cups or is cooling down her drink by spreading it into the saucer. Even the bracket-cut tray upon which the whole group is presented recalls a tea-serving salver. Though the figure-modelling is rudimentary, note the fine detail in the moulded patterns of the chairs, suggesting embroidery or fine carving.

In contrast to the delftware tradition, which was to 'whiten' the earthenware body by covering it with a film of opaque white glaze, Staffordshire potters of the lead-glaze tradition continued to refine their clay body to a creamy-white material generically referred to as 'creamware'. The material could be coloured, as here, by the application of coloured slip (the servant's head, details of the eyes), as well as with transparent metallic oxides, splashed and dribbled for colourful effect.

RIGHT Fig. 18 Staffordshire creamware tea party group, 1750–60, courtesy of Sotheby's, New York

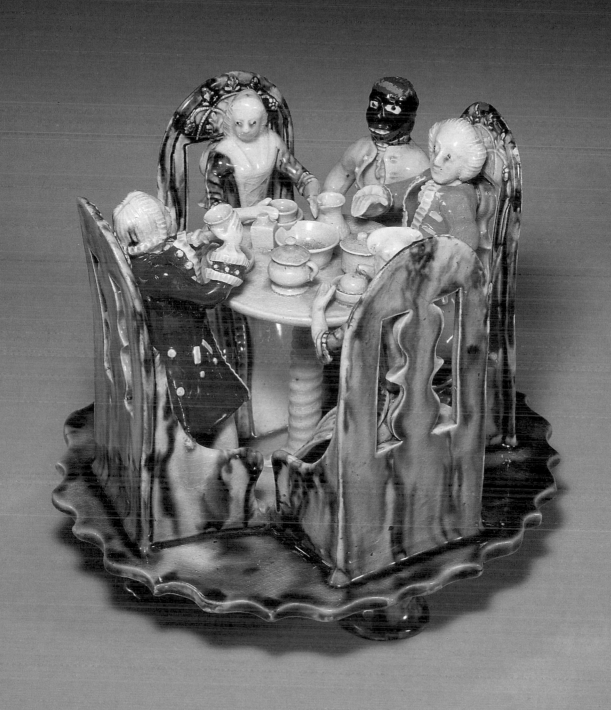

The Strode Family (opposite) shows William Strode Esq. seated at a table with his wife, Lady Anne (sister to the late Earl of Salisbury). Next to Mr Strode is his travelling companion Dr Arthur Smyth (later to become archbishop of Dublin) and behind Lady Anne stands Colonel Samuel Strode. At their feet sit two dogs: Mr Strode's spaniel and, it is supposed, the colonel's pug – though the latter seems uncannily similar to Hogarth's own dog painted approximately seven years later in his self-portrait (fig. 1, p. 16). At the centre of this 'breakfast-piece' we see the butler, Jonathan Powell, pouring hot water into the teapot as his master gestures to Dr Smyth to break off his studies and take tea.

The tripod tea table is dressed with a white tablecloth. The blue-and-white Chinese teapot appears to have been broken and given a replacement wood handle (and a silver spout?) emphasizing the value placed on even broken porcelain from the East.[8] It stands on a lobed tray of a form very like the 1743-dated tray illustrated in fig. 17, p. 29, though here almost certainly of silver rather than delftware. The tea bowls and saucers are typical Chinese porcelain of the 1730s while the cream jug and spoons are of silver.

Most valuable of all is the tea caddy box. Befitting its importance it occupies centre stage, at the feet of the mistress of the house. Its dimensions suggest that it contains three caddies or perhaps two with a central sugar bowl.

Compared to his earlier and grander compositions (for example, *Assembly at Wanstead House* (ca. 1729–31; fig. 10, p. 23) and *The Wollaston Family* (ca. 1730; private collection), the scene is intimate and domestic. This reflects an increasing informality throughout polite English society towards the middle of the century, tea-drinking no longer being quite so ostentatious as before, though being able to drink tea whenever *chez soi* is a statement in itself.

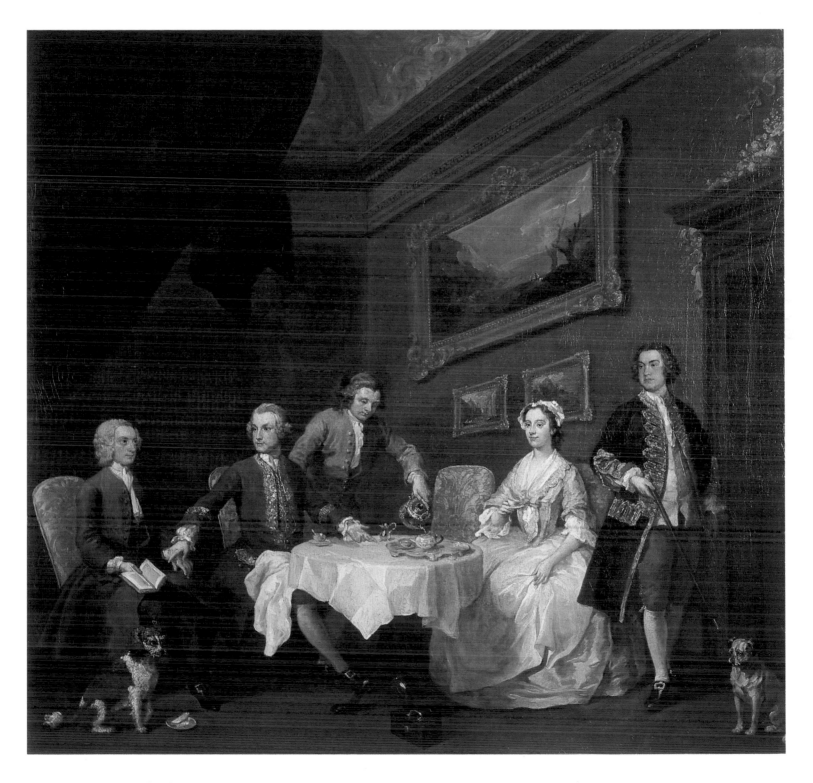

Fig. 19 William Hogarth, *The Strode Family*, 1738, Tate Gallery, London

A Harlot's Progress

Fig. 20 William Hogarth, *A Children's Tea Party*, 1730, National Museum and Gallery, Cardiff

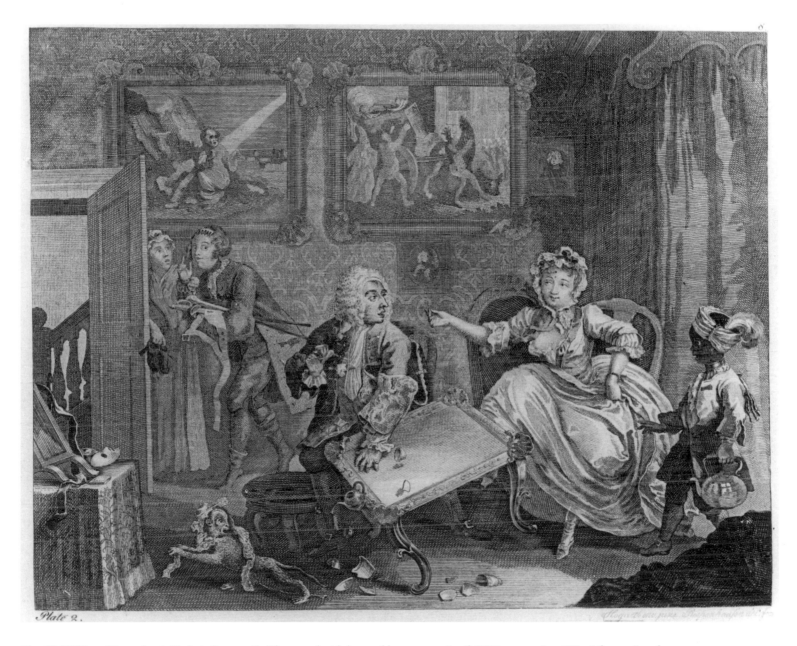

Fig. 21 William Hogarth, *A Harlot's Progress II: The quarrel with her wealthy protector*, April 1732, engraving, Witt Library, London

Throughout his life Hogarth was drawn to the spirit of childhood. Many of his finest works are those featuring children, for example *The Indian Emperor* or *The Conquest of Mexico*, 1732–33 (private collection); *The Cholmondeley Family*, 1732 (Marquess of Cholmondeley); and *The Graham Children*, 1742 (National Gallery, London).

In *A Children's Tea Party* (fig. 20, p. 34) an unruly spaniel has tipped the dolly's tea table. Though the girl in the foreground reaches out, she is already too late to prevent a mini ceramic disaster, the splintered shards of a toy tea service having already fallen to the ground. Hogarth used these very elements in the second of his *Harlot's Progress* series (fig. 21, p. 35): the girl's expression of surprise (the black boy), the tilt and contents of the tea table as well as the rush of the dog (taken up by the monkey).

Painted in oils over two years, *A Harlot's Progress* was the first of what Hogarth was to call his 'Modern Moral Subjects'. The pictures were painted out of sequence, starting with III (fig. 26, p. 42), where we find the attractive but already fallen heroine. As Ronald Paulson has shown,[1] many elements of the full series contain specific references to recent events and scandals, one of which involved the adventures of a young woman called Hackabout. Hogarth's use of topical persons and events played a large part in the instant success of the series, the eager subscribers including the wits of London, readers of *The Spectator* and those ever-present numbers interested in scandal. Nevertheless, the full story is essentially Hogarth's own invention: I – a young girl arrives from the country and is instantly 'spotted' by a madam; II – she takes up with a wealthy merchant but spoils her good fortune by two-timing him with younger lovers; III – she is reduced to common prostitution; IV – she is arrested and forced to beat hemp in a house of correction; V – with the additional burden of a young child she returns to her old trade but succumbs to disease and to the equally dangerous 'cures' of rival quack doctors; VI – finally she dies, surrounded at her wake by hypocritical mourners picking over the trifles of her belongings while her son, hardened to the world about him, fiddles with a toy.

Hogarth was breaking new ground with such a bold narrative sequence. In order to maintain a strong sense of 'progress' (signifying a forward motion while also carrying a heavily sarcastic figurative meaning), each image contains a door leading to or from the adjacent image in the unfolding story. One room leads to the next: one action leads to its consequence. In this way, as with all good drama, the author builds up our foreboding, an anticipation of disaster. Thus falling buckets, tipped-over china and crashing furniture all sustain the heroine's continuous, slow-motion fall. Breaking and broken ceramics feature in three out of the six images: first, the wilful destruction of an expensive porcelain service from China; the coarse use of a tea service, charged with a stronger brew from the contents of a cracked punchbowl; the second, more ominous fall of china from a coffin stool, linking death to the earlier, more light-hearted tea table. In the final image the only true expression of grief or agitation comes from a woman fortified by the 'Nants' brandy placed beside her in a stoneware bottle – clearly a bellarmine, decorated with a grinning mask – Hogarth signing off with a final ceramic flourish, an empty laugh to a tragic sequence.

A Harlot's Progress II

This picture is a bold parody on the popular and genteel tea ceremony conversation pieces with which Hogarth started his career – 'conversation' referring to a grouping of people, not necessarily engaged in talk (see figs. 10 and 32, pp. 23 and 46). The hostess is a whore. Its iconoclasm reaches out with a swipe at that fashionable badge of taste, porcelain.

In order to create a diversion Miss Hackabout tips the tea table, sacrificing its expensive porcelain wares. Her wealthy merchant lover gasps while managing to retain the

Fig. 22 Collection of Chinese export porcelain teawares, 1740s, Burghley House, Lincolnshire

delicate balance of his surviving precious tea bowl and saucer. Appalled at the girl's inexplicable petulance, he is unaware that her younger lover is thereby being given an opportunity to make his escape. Meanwhile the little black boy servant stretches out his hand in horror, his eyes popping at the cascade of china before him.

His training as an engraver secured Hogarth's success and fortune. He personally engraved the six *Harlot* prints based on his own paintings, made available for inspection by any potential public subscriber. In this way he raised a list of

over 1200 names at a guinea per series and by-passed the customary link from artist to engraver to printseller. He also retained all future control of his own copper plates. However, not until the copyright law was enacted (four years later, in time for *The Rake*) could he prevent the numerous 'pirate' editions cashing in on his own images.

When Sir James Thornhill saw Hogarth's original paintings he apparently became reconciled to his former pupil and now son-in-law (Hogarth had eloped with his daughter): "Very well; the man who can furnish representations like these, can also maintain a wife without a portion."[2]

The first porcelains exported to western Europe from China arrived via the Portuguese East India Company in the sixteenth century, and wares from Japan via the Dutch East India Company in the seventeenth century. Being made of a seemingly magical substance, such pieces – however modest in size or decoration – were given high status and frequently mounted in silver or gold.

In the early eighteenth century, with the emergence of the Honourable East India Company, England's links with China became stronger and more frequent. Along with tea, the trade in porcelain became more and more important. Families could commission an extensive dinner service, each piece charged with their own crest or full coat-of-arms. Their choice might be assisted by a special pattern book in which the whole range of possible border styles and panel subjects appeared. As for colour schemes, blue-and-white was the cheapest option (requiring only one firing), while services painted in enamels (*famille-verte* and – after *ca.* 1720 – *famille-rose*) afforded opportunities for extravagance and show. The falling china in *Harlot II* might belong to either category.

Without the original painting (all six of the series almost certainly perished in the fire at Fonthill Abbey in 1755, the same fire from which Hogarth's next Modern Moral series *The Rake's Progress* was rescued)[3] we cannot see precisely how the ceramics are decorated, whether enamelled in

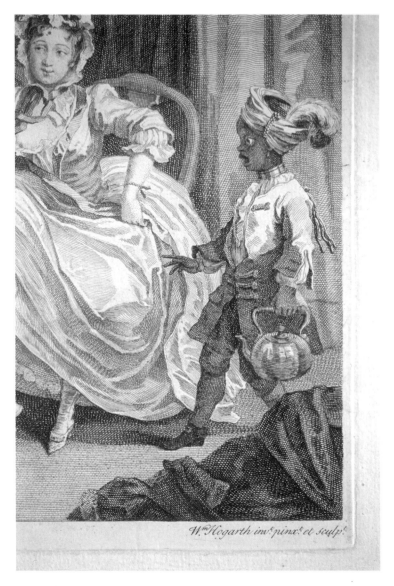

Detail from fig. 21, p. 35

colours or painted in the less expensive underglaze blue. Although services from one of the Continental porcelain factories (such as Meissen) were certainly in use in the 1730s, by far the majority of porcelain in England at this time was Chinese.

All the shapes – the teapot, slop bowl, cups and saucers –

are consistent with a Chinese tea equipage of a type exported in millions from Canton in the ships of the East India Company, decorated in the *famille-verte*, *famille-rose*, Chinese-Imari or just plain underglaze-blue techniques; with flowers and gardens, landscapes or figural scenes and in some cases a specially commissioned armorial service.

As no one had as yet succeeded in producing porcelain in the England of 1732, 'china' was highly regarded and, as we can see from Hogarth's more conventional conversation pieces, had become a must for any fashionable household. To see these treasures tipped on to the floor would certainly have been an upsetting experience for Miss Hackabout's merchant mentor. Whether or not he knew of the actual cause, a consequence of his companion's action is a curtailment of their liaison, forcing Hackabout into the rougher trade of the images which follow.

A major claim to fame of Dr Wall's Worcester factory was its extensive use of transfer-printing as a decorative technique (see fig. 23). This allowed high-quality images to be reproduced in quantity, saving time and making porcelain more affordable by a wider group of clientele.

Previously used on tin-glazed earthenwares as well as on creamware, the technique was brought to a new degree of perfection by the engraver Robert Hancock (1731–1817). In 1746 Robert Hancock was apprenticed to George Anderton in Birmingham as a transfer-print engraver. After completing his apprenticeship he was employed by the Worcester porcelain factory where within a few years he created a unique legacy of transfer-printed wares.

He produced many different prints, nearly all of them adaptations of the work of other artists including Joshua Reynolds, Thomas Gainsborough and François Boucher. Among his early prints, to be found on both Worcester and Bow porcelain,[4] is *The Young Archers*, after an original print by Gravelot, which had been executed around the time of Hogarth's *Harlot* series. Hubert François Gravelot,[5] possibly the most influential of the artists who met at Old

Fig. 23 Worcester porcelain tea caddy, transfer-printed with *Maid and Page*, *ca.* 1765, private collection

Slaughter's Coffee-House in St Martin's Lane, collaborated with Hogarth and Hayman in the decorations at Vauxhall Gardens; he may also have influenced the work of the silversmith Paul de Lamerie.

As with the delftware tray (fig. 17, p. 29), scenes of tea-taking were a natural choice for the decoration of any ceramic tea utensil or accessory. Hancock produced several designs showing couples taking tea out of doors attended by a maid or by the obligatory black serving boy. They

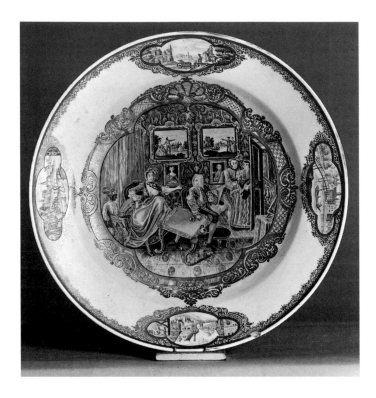

Fig. 24 *Hausmaler*-decorated Meissen saucer, *ca.* 1740s, Victoria and Albert Museum, London

feature on teapots, caddies, jugs, spoon trays, cups and saucers.

Of over one hundred examples of Robert Hancock's prints on Worcester and Bow porcelain, the image seen in fig. 23 is the only one directly traceable to William Hogarth – and here only in part. The page is the same black servant who in *Harlot II* reaches out in horror as the china crashes to the floor. Although the scene into which he has been dropped on this Worcester tea caddy – showing a maid arranging a tea table out of doors – should give the page no cause for alarm, Hancock leaves the expressions of surprise unaltered: note the outstretched, splayed fingers as well as the startled eyes. Skilled engraver though he was, Hancock was a copyist, not an original artist. Only one other near-Hogarthian element occurs in the remainder of Hancock's known works (see fig. 67, p. 79). Certainly by the time the Worcester factory was under way, the full Modern Moral Subjects were seen as too old-fashioned to find favour with the makers and users of the exotic new material now being produced at home.

Porcelain manufacters both in Germany and England supplied undecorated porcelain to outside decorating workshops. In England the most prolific was the London atelier of James Giles (active *ca.* 1760–80), receiving blanks from Worcester, Bow and possibly Chelsea. So successful were his wares that they started to challenge those of the manufacturers. Earlier, in Germany, white wares from Meissen and Vienna reached the enamellers of Augsburg, Silesia and Bohemia. But as the quality of the decoration was highly variable and beyond the direct control of the manufacturers, they soon restricted the supply and

prohibited artisans from working in independent ateliers.

According to Dr Ingelore Menzhausen, the Meissen group known as 'the Lady on a Visiting-stool' (below) was inspired by *Harlot II*.[7] Hogarth's images were particularly popular in the German principalities of Berlin and Dresden, so it is indeed possible that an artist working at Meissen might have been acquainted with his works, like the decorator of the Meissen saucer in fig. 24. However, the versatility of such groups, of which the modellers were capable of substituting a figure for a table and *vice versa*, makes it difficult to argue a definitive derivation from any particular print source. In this instance the gentle humour

of a lady more interested in the distraction of her servants or clown, while her gallant suitor succeeds only in receiving the attention of her lap-dog, is altogether different to the violence of Miss Hackabout's temperamental behaviour. Rather than any direct link to Hogarth, it seems probable that the Meissen modeller was simply depicting a familiar conjunction of universal mid-eighteenth-century elements: a lady, a tea or coffee table and a black boy – the standard conversation piece. Indeed, the very same elements, plus a fawning courtier, occur in *Marriage IV* (fig. 75, p. 88), a work painted at least six years later than the Meissen group.

Fig. 25 'Die Dame auf dem Visitenstuhl (Lady on a Visiting-stool)', Meissen porcelain group, 1740s, courtesy of Christie's, London

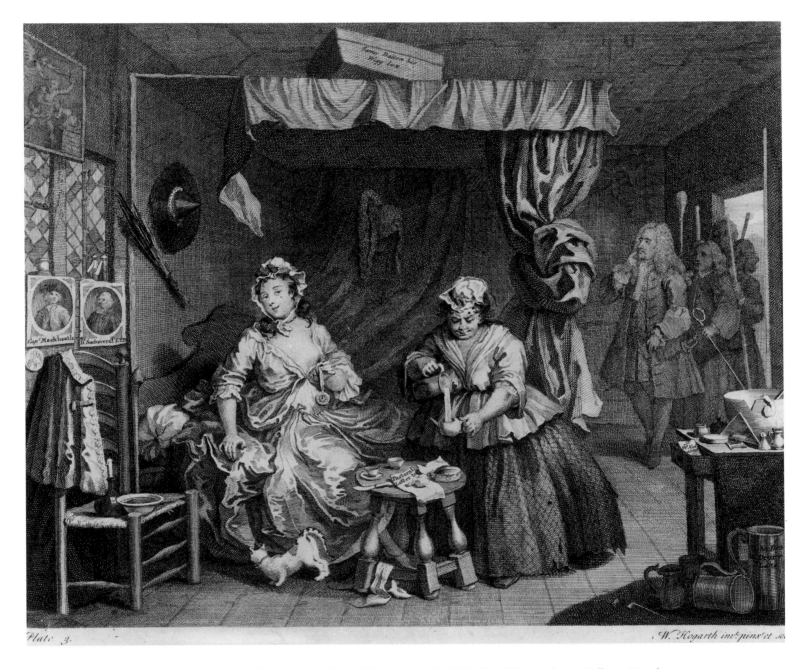

Fig. 26 William Hogarth, *A Harlot's Progress III: Apprehended by a Magistrate*, April 1732, The Whitworth Art Gallery, Manchester

Though third in the full *Harlot* series, this appears to be Hogarth's first in terms of execution, being derived from an earlier drawing in red chalk dated *ca.* 1730.[8]

Since her tiff at the tea table, Miss Hackabout has fallen into rougher lodgings. The genteel tea table has been replaced by a coffee stool. From her salvaged porcelain

service, we see she still clings to certain social niceties, though her teapot is crudely filled, presumably with the much stronger brew which stands in the broken punch-bowl to one side of the room. Among the other ceramic details are a bowl placed on the bedside chair and a little jar on a ledge by her bed, possibly for a medicinal salve. Next to it stand two medicine bottles which testify to the presence already of the disease and infection which will later blight and eventually claim Hackabout's life.

The posse entering at the door is led by Mr Justice Gonson, well known scourge of harlots, come to arrest Miss Hackabout. On the wall, next to her 'pin-up' of highwayman Macheath, is a portrait of the High Church rabble-rouser Dr Henry Sacheverell (see fig. 27).

While accurately re-creating the contents of a Drury Lane harlot's bedchamber, Hogarth uses these ceramic props as symbolic and pointers in the narrative. Humour and danger are poured in equal doses, corresponding to the bed curtains tied with the ominous twin masks of Comedy and Tragedy.

In 1710, when Hogarth was thirteen, he would have witnessed London's worst riots for many years. At a time when the country was still divided between the Catholic Jacobite cause and the Protestant House of Orange, and with older memories of republican Puritanism lingering, religion was still a potent and emotional force. Thus it was that Dr Henry Sacheverell, a firebrand High Church priest, had been able to stir the populace to religious hysteria with his series of provocative sermons preached against forces perceived as undermining 'the true Church of England'. Hogarth himself came from a Low Church background and, twenty years on, would have recalled the earlier sense of danger and unease when the former firebrand was seen to have turned into an Establishment figure.

Despite his earlier rôle as rabble-rouser, Sacheverell was

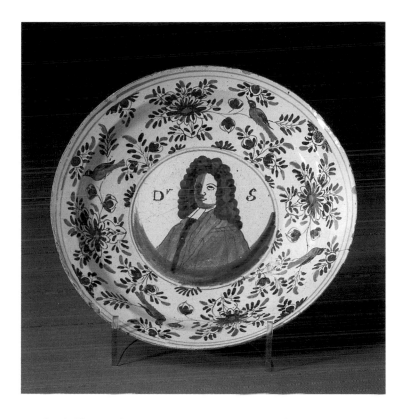

Fig. 27 Delftware plate decorated with the portrait of Dr Sacheverell, ca. 1730, Royal Pavilion Art Gallery, Brighton

given preferment at court, generating, as late as July 1731 (just as Hogarth was working on the *Harlot* prints), indignant questions in *The Free Briton* as to why this man should be given favours.[7] It was an example of religious cant which, remembering the menace of a crowd incited against his own family's freethinking religious beliefs, clearly stung Hogarth's ironic nerve.

Placing Sacheverell side by side in *Harlot III* with Macheath (John Gay's fictitious highwayman who in *The Beggar's Opera* is given a reprieve despite his many crimes), Hogarth points to hypocrisy and gives his heroine hope of reprieve just as she herself is about to be arrested.

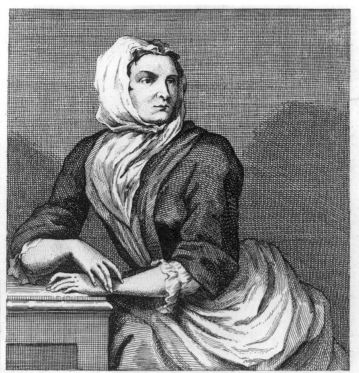

Fig. 28 William Hogarth, *Sarah Malcolm*, March 1732/33, engraving, Royal Pavilion Art Gallery, Brighton

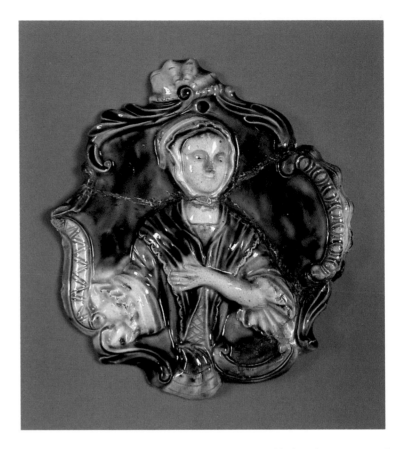

Fig. 29 Staffordshire creamware wall plaque, moulded with a portrait of Elizabeth Canning, *ca*. 1750, Royal Pavilion Art Gallery, Brighton

Before the advent of creamware and porcelain transfer-printing, both mainstream ceramic traditions, delftware and earthenware, were producing commemorative wares. Just as the delftware factories had begun to issue chargers, plates (see fig. 27, p. 43) and drinking vessels, so the lead-glazed earthenware factories turned to issues of the day.

In 1753 a nineteen-year old servant called Elizabeth Canning claimed she had been abducted by a gypsy, Mary Squires. Squires was found guilty, but after the trial Canning gave newspapers so different a version of events that she was arrested and tried for perjury. In May 1754 she was found guilty and transported to America. The Canning affair became a *cause célèbre* and caused china merchants to com-

mission porcelain mugs bearing portraits of the two women (see fig. 31) based on an engraving by R. Cole (fig. 30).

Canning's pose of hand on heart – as if taking an oath – led collectors to misidentify the lady on plaques like fig. 29 with another *cause célèbre*, that of Sarah Malcolm. As she awaited execution for the murder and robbery of her mistress and a maid, Hogarth and his father-in-law, Sir James Thornhill, were permitted to visit her in prison, where Hogarth sketched her portrait in oils, from which came the painting followed almost instantly by the print (see fig. 28). Issued after her execution in March 1732–33 it was so successful that pirate editions soon appeared.

The white or bluish-white ground of tin-glazed earthen-

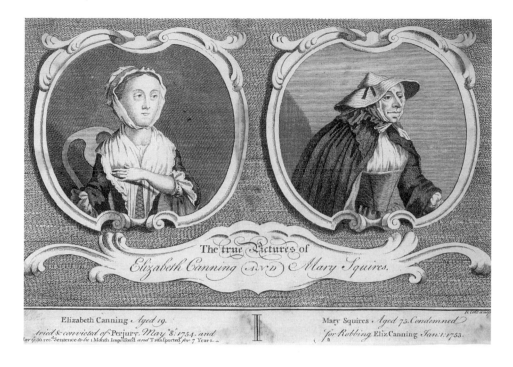 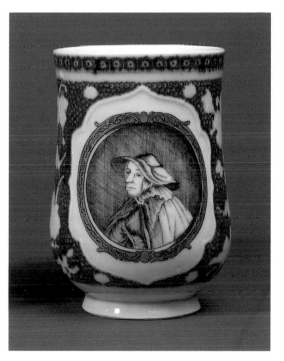

LEFT Fig. 30 R. Cole, *Elizabeth Canning and Mary Squires, ca.* 1754, engraving, private collection
RIGHT Fig. 31 Chinese export porcelain mug decorated with portraits of Mary Squires and Elizabeth Canning, *ca.* 1754, private collection

wares offered an ideal canvas for metallic oxides – blue, manganese, yellow, red and green. Events covered by the many dated survivors of the seventeenth and eighteenth centuries include domestic and personal commemorations (often marriages), coronations and a large number of maritime subjects: sea battles (Portobello), naval heroes (Vernon, Howe and Rodney) and individual ships, particularly during the first half of the eighteenth century as English maritime power grew – a trend boosted by the fact that the majority of delftware ceramics were manufactured and shipped out of the great port towns and cities (London, Bristol, Liverpool and Dublin).

Meanwhile, the more ancient lead-glaze tradition, dominated by the inland potteries around South Staffordshire, also produced royal, patriotic and domestic commemora-

tives, at their most elaborate typified by the multicoloured slipwares of the Toft and Taylor families (see fig. 53, p. 67).

Though the humbler slipware tradition continued well into the nineteenth century, by the third quarter of the eighteenth century its multicoloured exponents had given way to simpler utility forms. New traditions such as salt-glazed white stoneware and creamware, and the wider availability of porcelain, caused the British delftware industries to fall into rapid decline, being virtually extinct by 1800.

The revolutionary use of transfer-printing encouraged a massive proliferation in commemorative wares, from topical satire to propaganda. With one or two exceptions this happened too late for the particular issues, subjects and style of William Hogarth. One of those exceptions was to be *A Midnight Modern Conversation.*

A Midnight Modern Conversation

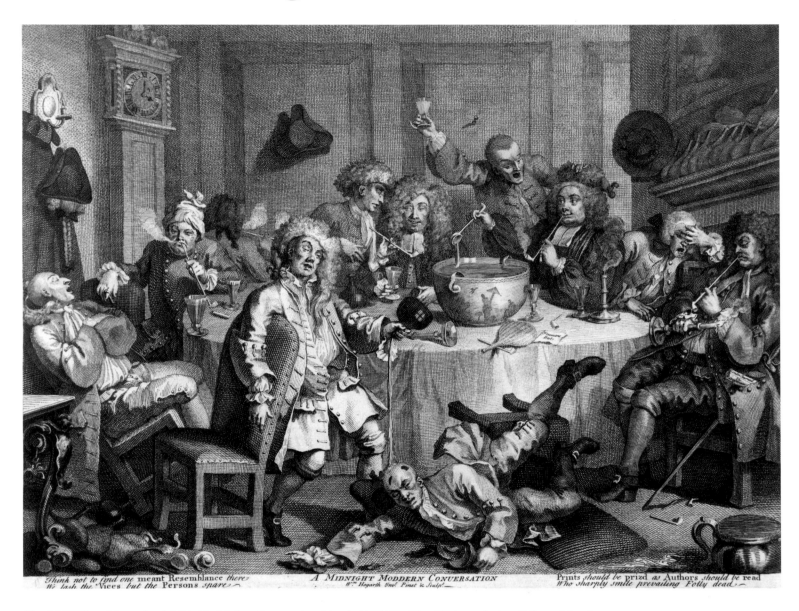

Fig. 32 William Hogarth, *A Midnight Modern Conversation*, March 1732/33, The Whitworth Art Gallery, Manchester

As we have seen, the growing demand for coffee, tea and chocolate had stimulated the whole ceramics industry, both at home and abroad, with increasing amounts of Chinese porcelain brought in by the tea-importing East India Company. Another new drink, punch, gave yet further impetus to the makers and importers of china and pottery wares.

The word 'punch' is probably derived from the Indian word *pānch* meaning 'five', the staple number of ingredients for a typical recipe. In other words, we again look to the East and to the East India trade for the transmission and popularity of this drink.

Alcoholic brews with various ingredients had been known well before the eighteenth century, one of the most popular seventeenth-century drinks of this type being posset, a potent mixture of alcohol (wine or beer) with various ingredients curdled with hot milk. Special vessels – posset pots – had been constructed whereby the head of ingredients could be bypassed through an upright tube which connected with the bottom of the vessel. As well as silver examples of such vessels, the English delftware industry produced a whole range of lidded vessels. Some were even surmounted by an elaborate crown, indicating the owner's allegiance to the monarch. Of the posset pots which survive today, many incorporate a date within the design, as do many punchbowls. By comparing the relative frequencies of the two it becomes clear that by the 1720s both drinks were level-pegging, with posset in decline and punch on the rise, the latter reaching its peak in the 1740s.[1]

Hogarth seems to have been triggered into making *A Midnight Modern Conversation* by the uproar which greeted Robert Walpole's announcement of the Excise Bill, aimed at taxing tobacco and wine. It is therefore hardly surprising that this engraving, a tribute to those very pleasures, became the most copied and widespread in ceramics of all Hogarth's images. Within a month of its publication, on 1 March 1733, it had been adapted into a ceramic context.

At first it was seized upon for specific or generalized versions by the native salt-glaze stoneware manufacturers (see figs. 35 and 36, pp. 50 and 51); at about the same time it was captured by the native English delftware makers (see frontispiece); while in continental Europe, the Dutch potters in Delft also found the image to their liking (see fig. 38, p. 52), as did the porcelain decorators at Meissen (see fig. 39, p. 53) and, into the nineteenth century, in Berlin. Two particularly fine examples of the scene are to be found on Chinese porcelain punchbowls made for the western market (see fig. 40, p. 54).

Although in all cases the decorator would, of course, be working from a print, it is interesting to note that on these porcelain examples the painter has depicted the central bowl as a blue-and-white piece. This choice would either have come naturally – by far the majority of porcelain and pottery punchbowls being decorated in blue – or (especially in the case of the Chinese decorator) may have been prompted by the careful annotation of colours on the print sent out with the commission.[2]

The 'Midnight' of the title is ironic. The time on the long-case clock in fact reads four o'clock in the morning (as it had on the bracket clock of Hogarth's original painting, executed *ca*. 1730).[3] Eleven gentlemen in varying degrees of intoxication are gathered around a table: from the supine prize-fighter to the still upright cleric. The 'Conversation' of the title is also partly ironic since, whatever its quality several hours earlier when the punch began to flow, any conversation must by now have reached an ebb. Nevertheless, the word 'conversation' still holds good at its more general definition, signifying any gathering or party of people, just as in the more genteel conversation pieces around the tea table (for example figs. 10 and 19, pp. 23 and 33).

This print was published less than one year after the success of the *Harlot*, which owed a good deal of its instant popularity to Hogarth's seizing on topical events and

47

mugs. Versions most closely following the Hogarth original, complete with James Figg the falling prize-fighter, are rare (see fig. 35, right). Of the many familiar punch-drinking scenes appearing as friezes on stoneware mugs, tankards and jugs throughout the eighteenth century, by far the majority are merely loose adaptations, with a serving wench added to one side.

Salt-glazed brown stonewares were thickly potted and fired to much higher temperatures than earthenwares and are undoubtedly the sturdiest of all eighteenth-century ceramic wares. Tough and resilient they were ideally suited to the rough and knockabout environment of taverns, inns and pubs. They would also have been in common domestic use even if kept behind the scenes in more well-to-do houses. Considering their ubiquity it is perhaps surprising that no Hogarth images seem to capture this common ceramic group.[7]

Although it has the thinness and whiteness of china, Staffordshire white stoneware is not translucent. Though clearly not porcelain, it did offer a very passable imitation of this prestige material. Its consistency allowed it to be moulded or slip-cast which, combined with the salt-glazing technique, gave the surface a much creamier, more tactile quality than most porcelains. Its quality was recognized and, until the arrival of English porcelain in any quantity, Staffordshire white stoneware gained a ready market on the tea table. Unlike coarse brown stonewares, white stoneware leant itself to the manufacture of all the refined wares of the tea table.

The material evolved out of an endeavour to produce a truly white clay, using refined Cornish china clay. It was this same pipe-clay material which, fired to a lesser temperature and given a lead glaze, transformed stoneware into creamware. Unlike creamware, however, white stoneware (more usually a putty-grey in tone) lent itself well to enamel decoration in the *famille-rose* style.

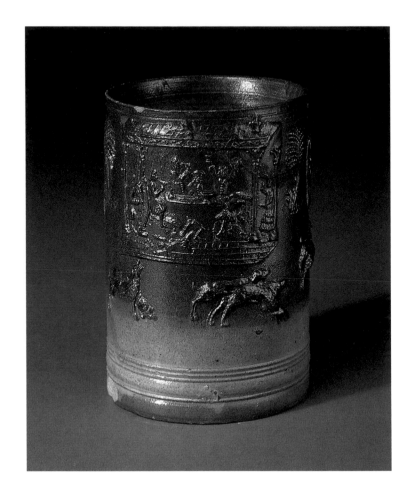

Fig. 35 Brown salt-glazed stoneware mug moulded with *A Midnight Modern Conversation, ca.* 1733, Royal Pavilion Art Gallery, Brighton

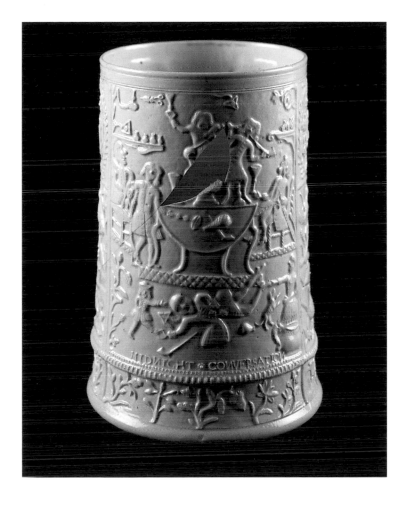

Fig. 36 White salt-glazed stoneware mug moulded with *A Midnight Modern Conversation, ca.* 1733, Museum of London

It is impossible to say whether some or any of the white vessels or dishes pictured by Hogarth are of salt-glaze stoneware. But it would certainly be surprising if he had not encountered the material during the 1740s and 1750s before it was replaced by porcelain. The best candidate perhaps is the beer jug standing on the floor in the suicide scene of *Marriage à la Mode* (see fig. 78, p. 91).

Since the seventeenth century the Dutch had been masters of tavern scenes: figures carousing, lubricated by drink and attended by wenches. In Hogarth's image they would have recognized their own tradition in pastiche. (An echo, even, of Rembrandt's celebrated image of physicians

Fig. 37 Meissen porcelain punchbowl decorated with *A Midnight Modern Conversation*, 1750s, Victoria and Albert Museum, London

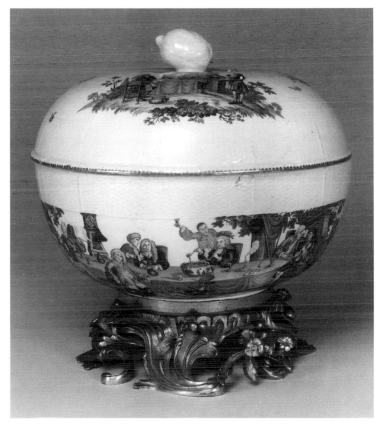

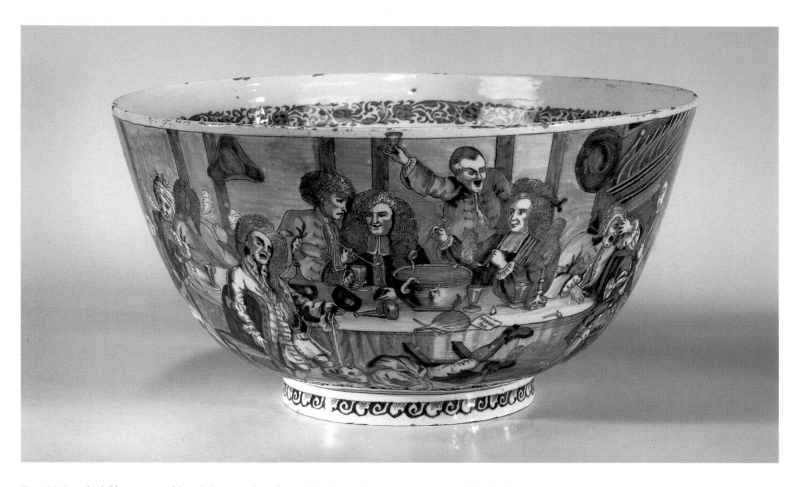

Fig. 38 Dutch delftware punchbowl decorated with *A Midnight Modern Conversation*, 1750–70, Rijksmuseum, Amsterdam

conducting a dissection?)[8]

Of all Hogarth's images on punchbowls, the Dutch delftware bowl shown above ranks among the boldest translations from two to three dimensions. By the mid eighteenth century in England punchbowls had tended to widen out, closer to the Chinese pattern, and here the steepness of the bowl has helped the artist. In this respect also the bowl more closely resembles that on the table of the image.

Note how, when placing the raised glass of the animated toaster, the artist has had to run over the upper line border. Quite accidentally *a trompe l'œil* effect is achieved.

The steep-sided bowl seen in fig. 39 is made of porcelain. Rather than filling the space the artist has spread and scaled down the figures, transforming the entire coffeehouse to a garden where the background of white sky improves the drama of the subject. Had he not done so, of course, the dark panelled background would have enveloped and smothered the characters. (The same technique is repeated in a whole series of Berlin punchbowls into the nineteenth century: see fig. 101, p. 113). The enameller is clearly working directly from a print – evident in his transcription of the note on the edge of the table.

A number of European states set up their own East India

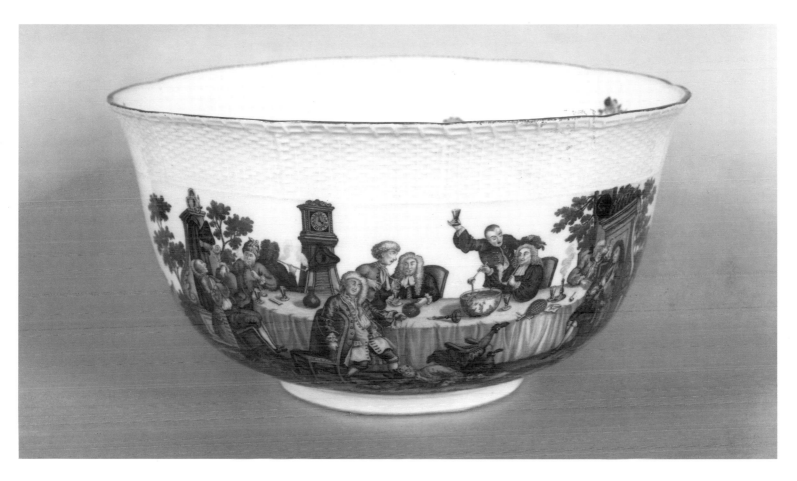

Fig. 39 Meissen porcelain punchbowl decorated with *A Midnight Modern Conversation*, 1750, Rijksmuseum, Amsterdam

Companies in the eighteenth century. England's own United Honourable East India Company was amalgamated in 1708, bringing together rival enterprises which had been founded earlier in the seventeenth century. Holland's own Verenigde Oost Indische Compagnie had also been trading with the Far East throughout the seventeenth century, in particular with Japan where they had been able to lever heavily against the oldest of the European East India Traders, the Portuguese.

The 1600s had been a momentous period for China: at the beginning of the century the ruling Ming Dynasty was in irreversible decline. By the 1680s the new Qing Dynasty had finally established itself and trade could be resumed. This dealt a blow to the Japanese who, until this point, had reaped profits from China's turmoil, allowing its own much younger porcelain industry to fill the gap in supply.

For the first half of the eighteenth century the East India trade with China prospered: *famille-verte* wares gave way to the wider palette of the *famille-rose*. In addition to specially commissioned armorial services, European clients commissioned exact copies of popular engravings of both religious and lay subjects. Many were content with the simple but often charming underglaze-blue and Chinese Imari wares, while others demanded the full enamel treatment. On rare

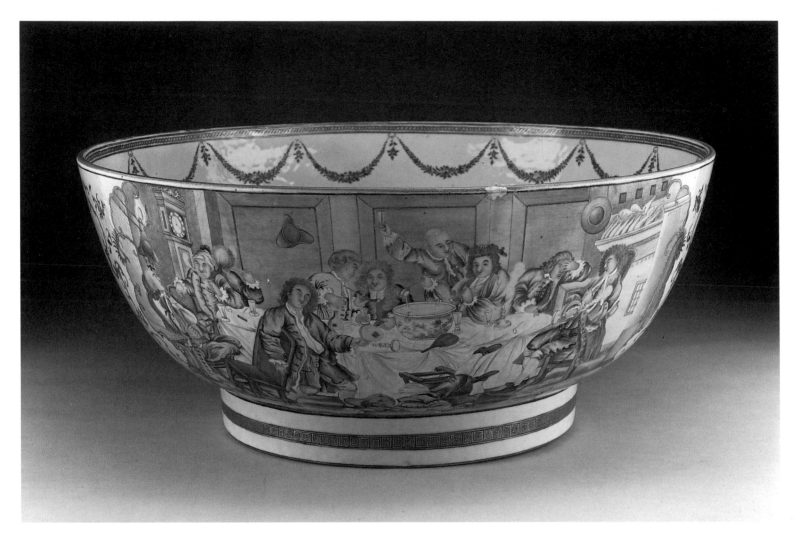

Fig. 40 Chinese export porcelain punchbowl, first view showing *A Midnight Modern Conversation*, second view showing a party of Chinese gentlemen enjoying a feast, *ca.* 1750, private collection

occasions the Chinese decorator would be permitted to bal-ance European and Chinese decoration in equal measure. The massive bowl shown above is one such example.

Painted in *famille-rose* enamels, the bowl shows on one side *A Midnight Modern Conversation*, on the other a party of Chinese gentlemen enjoying a feast. The bowl is a remark-

able synthesis in terms of potting, quality of decoration and rarity of subject-matter, as well as a playful moral comparison.

The contrast between the two scenes could hardly be greater. On one side intoxicated and unruly Westerners, each individual personifying a totally different state from

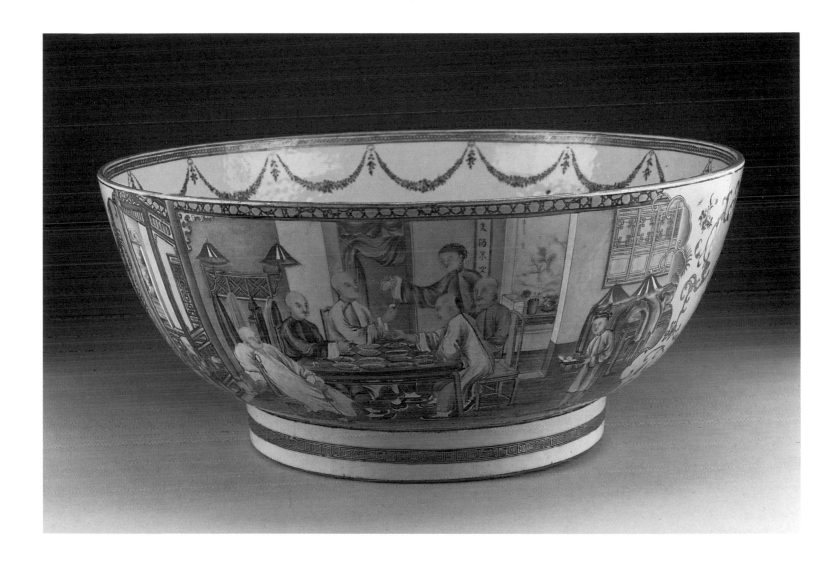

that of his neighbour; on the other side a harmonious and sober Oriental gathering conveying calm and gentility, with tea being served.

In sending out Hogarth's print to be copied, the European client would almost certainly have stipulated this humorous juxtaposition, having perhaps personally experienced such a contrast in his own dealings with the East India Trade.[9]

The features of the European revellers have gone distinctly Oriental and the painter has allowed himself to alter Hogarth's *chinoiserie* decoration to a straightforward blue-and-white bowl painted with a Chinese landscape.

Southwark Fair

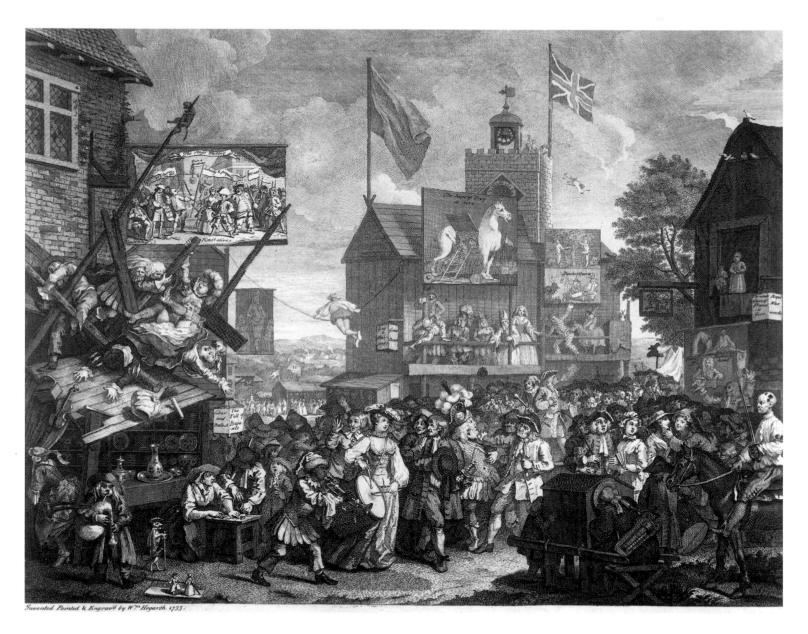

Fig. 41 William Hogarth, *Southwark Fair*, January 1733/34, engraving, The Whitworth Art Gallery, Manchester

Painted in 1733, *Southwark Fair*, the painting from which the subscription print was engraved, was Hogarth's biggest to date, measuring approximately 121.8 cm × 127 cm. Hogarth announced the engraving of the *Southwark Fair* print in October 1733, at the same time as *The Rake's Progress*, though the latter was not made available until the passing of the Engravers' Act (May 1735). In it Hogarth places recognizable elements of London's two major fairs: Bartholomew (familiar to Hogarth from his childhood) and Southwark – at both of which stage performances based on his own *Harlot's Progress* could be seen.

Appropriately, the two unifying themes of the picture are 'Theatre' and 'The Fall'. On the left 'The Fall of Bajazet' is advertised. In the distance an acrobatic sky diver and a rope walker are seen, framing a performance of the Fall of Troy – enacted all too literally by the unfortunate performers as their stage gives way. Beneath them, unaware of events, sits a china merchant (a common sight at all such fairs), her stand neatly decked out with a variety of doomed wares. In this instance her stock appears to be a mix of ornamental and useful wares, apparently of tin-glazed earthenware.

In this image Hogarth offers us the greatest single concentration of china in any of his works – and it is about to be crushed. As a focus of imminent disaster, Hogarth uses ceramics here, as in *Harlot II* (the falling tea table), to symbolize human vanity – Pride Goeth Before the Fall.

Striding through this mayhem appears a drummeress, one of Hogarth's most memorable figures.

Made in Bristol or London, the English delftware plate illustrated here shows a traditional English fair. Many of the elements of *Southwark Fair*, painted twenty-seven years earlier, are repeated: the cloth painted with the Trojan Horse; the tightrope walker; the harlequinade enacted on one of the covered stages; the traders' stalls and the figure of a drummer with a following crowd. The delftware painter has clearly copied a print, one possibly derived from Hogarth's painting.

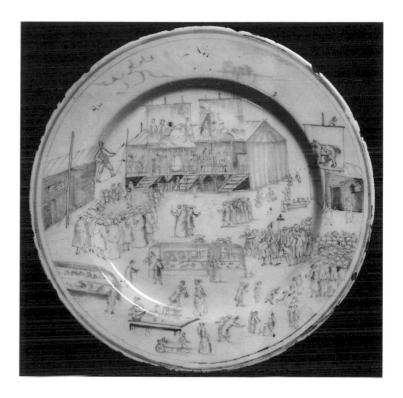

Fig. 42 English delftware dish decorated with a fair, dated 1760, Victoria and Albert Museum, London

The Rake's Progress

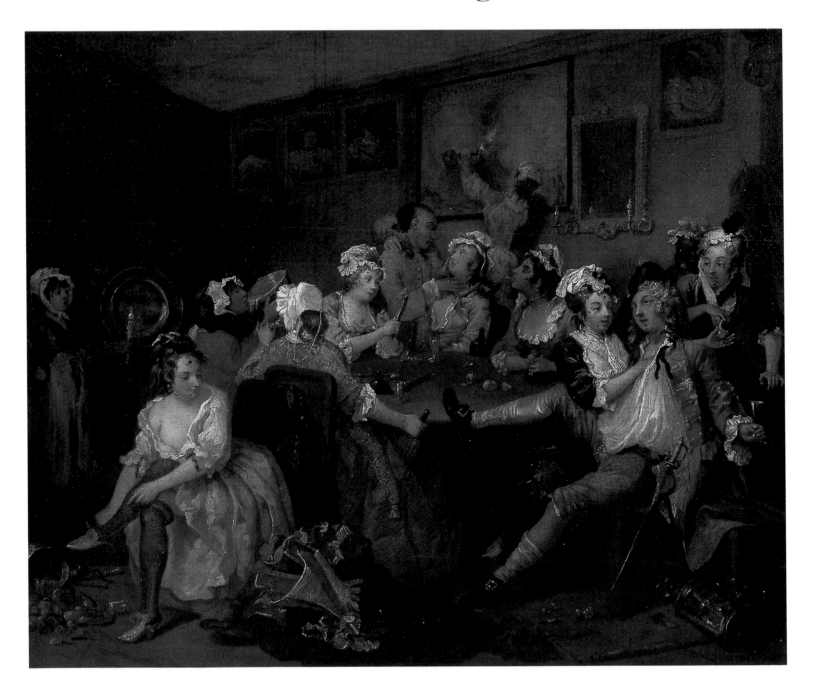

Fig. 43 William Hogarth, *The Rake's Progress III: The tavern scene*, June 1735, Sir John Soane's Museum, London

ogarth decided to follow up the success of his *Harlot's Progress* with a second series – *The Rake's Progress* – devoted to Tom Rakewell, a male counterpart to Miss Hackabout. He expands the six-part *Harlot* format to eight paintings in which we follow the brief rise and inevitable decline of the hero.

As in the *Harlot* each image is crammed with artefacts pointing to a reading of the story and its characters. These help in linking one image to the next and it is clear that the action has been plotted to flow from left to right in the engraved version of the image (that is, the reversal of the painted image).

The series commences with Tom inheriting money from a miserly merchant. With new visions of luxury before him, Tom jilts his pregnant girlfriend, Sarah Young, and is about to embark upon a life of ease. In the second image we see Tom establishing himself by buying all the accessories and vanities of a fashionable gentleman about town: the engagement of an Italian musician and of a fencing master (the same James Figg we have already seen in *A Midnight Modern Conversation*) and of works of art, for Tom has become a collector.

In *Rake III* (opposite) Tom has been led by his truer instincts to the rowdy world of the Rose Tavern in Drury Lane, at the heart of London's theatre world. Surrounded by prostitutes and steeped in alcohol he enjoys the attentions of a young woman who, while she fondles her client with one hand, delivers his watch to an accomplice behind him with the other.[1] On a floor strewn with lemons discarded from the mixing of punch, a fallen chamber-pot spills on to a speared leg of chicken.

In the fourth picture Tom is about to be arrested for debts. As he starts from his sedan chair, he is saved by the intervention of his former sweetheart, come to find him from the country. But Tom's debts and vices need more substantial support and in *Rake V* we witness his loveless union to an ugly but wealthy old woman. Having squandered his first fortune Tom now dissipates a second and in *Rake VI* (fig. 47, p. 62), having lost at the gaming table, he curses God for his ruin. In *Rake VII* Tom is found as a prisoner of the Fleet, surrounded by the detritus of harebrained schemes – wings for flight, a rejected play and a wild plan for the redemption of the National Debt (when he cannot clear his own). In *Rake VIII* the faithful and distressed Sarah Young follows Tom to his final scene – the Bedlam Hospital for the insane.

The tale is dramatic and harrowing, and takes Hogarth into subjects well beyond the pale of polite conversation pieces. Having recently lost an important commission to paint the royal family (on account of the intervention of his old enemy William Kent, his senior by more than ten years), Hogarth at this point embarks upon *Southwark Fair* and *The Rake* in an apparently conscious resolution to exploit the rich seam of subscription prints he had discovered with his *Harlot* and *A Midnight Modern Conversation*. To consolidate his position, along with other artists, he actively lobbied Parliament for the Copyright Act, allowing him to build his independence.

Few, but telling, ceramics appear in the eight-part series, the first found in the opening scene. Among the boots, swords and wigs in the open cupboard we discover a cracked mug or jug next to a punchbowl. They stand on a shelf beneath the flaccid pig-tails of dusty wigs, suggesting their former use as chamber-pots.

Tom's new lifestyle is exuberant, hence in the Rose Tavern we find a reveller slaking her thirst by taking straight to the bowl, spilling half the contents on to her clothing (see p. 49 for a discussion of the bowl). At her feet are scattered the ingredients of the punch-swilling orgy.

While neither of these images pins down exactly the ceramic ware, they do offer a realistic flavour of context. As the joviality of the *Midnight Modern Conversation* had sparked off a number of ceramic adaptations of the image, so Scene III of *The Rake's Progress*, the Rose Tavern

interior, gave rise to at least one and perhaps even three ceramic 'translations'.

The Chinese porcelain mug (fig. 44) painted *en grisaille* shows another Tom Rakewell in the clutches of two female companion. As in the case of so many European prints sent out to China for copying on to porcelain, the graphic source is revealed by the porcelain decorator employing the same cross-hatching technique used by the engraver to convey light and shade.

The posture of the young lady depicted on the punch-bowl in fig. 45, as she reaches down to tie her garter, is very similar to the lady to the right of the Rose Tavern scene: her head is turned slightly to one side and the front of her dress falls open, revealing all.[2] The costume differs from that of Hogarth's girl; the Chinese painter has failed to understand the construction of female European cloth-ing.[3] If the Hogarth image did give rise to the Chinese bowl, it was presumably through an intermediate artist, one

RIGHT Fig. 44 Chinese export porcelain mug decorated with an amorous scene *en grisaille, ca.* 1750, private collection
BELOW Fig. 45 Chinese export porcelain punchbowl decorated with a lady tying her garter, *ca.* 1750, private collection

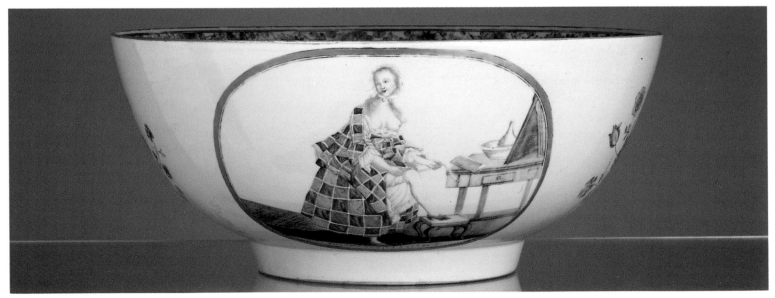

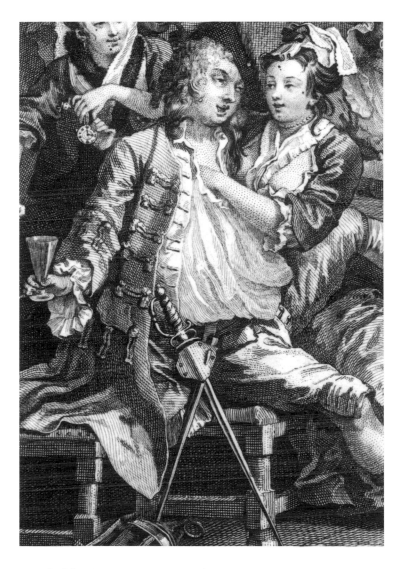

Detail of fig. 43, p. 58

Fig. 46 Meissen porcelain group of lovers, *ca.* 1740, courtesy of Christie's, London

who added the footstool, the dressing table with its guglet and basin and the chequered costume (note the chequered fabric worn by the young woman seated with her back to us in Hogarth).

We have already seen that both Meissen and Berlin decorators seized upon the earlier print of *A Midnight Modern Conversation* as suitable painted decoration for a punchbowl. Was Hogarth likewise a source for the modeller?

At first sight the pose of the Meissen group (above) of a courtly couple upon a seat may echo the embrace received by Tom Rakewell. However, the sentiment of the two situations could hardly be more different: in Hogarth the man

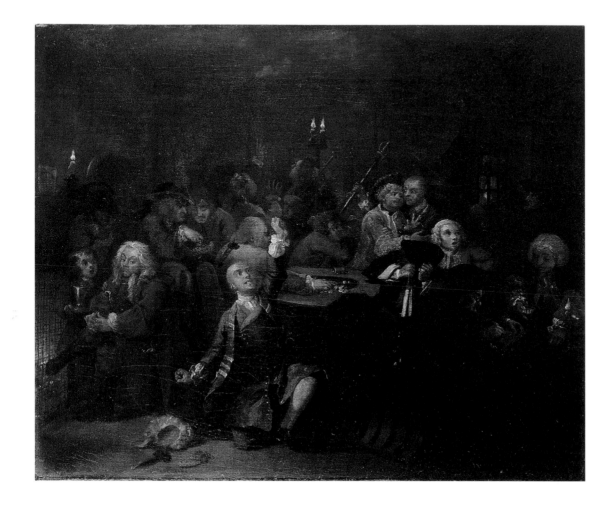

Fig. 47 William Hogarth, *The Rake's Progress VI: Scene in a gaming house*, June 1735, Sir John Soane's Museum, London

is heavily intoxicated and passive to the fumblings of his girlfriend, his leg slung over her lap as she robs him; Kändler's group, on the other hand, depicts a tender moment between equals in everyday life. Though the chronology could fit, with Hogarth's print published a year earlier, the detail casts doubt upon any direct link.[4]

The nineteenth-century covered Berlin punchbowl shown opposite combines a number of different Hogarth scenes from various series. On the bowl itself we find *A Midnight Modern Conversation* (outside) and a banqueting scene from the later series *Industry and Idleness*. On the

cover (suggesting that the intended contents were hot) the decorator has used *Evening* from the *Four Times of Day* series (fig. 56, p. 70) and *In a gaming house* (fig. 47, above), the sixth picture of *The Rake's Progress*, all surmounted by a Bacchic putto.

In continental Europe Hogarth's images remained popular well into the nineteenth century, at a time when his moral subjects would have jarred the delicate Victorian sensibilities of his own country. Several Hogarthian Berlin punchbowls have been recorded, with a variety of combinations of images from different series, as here.

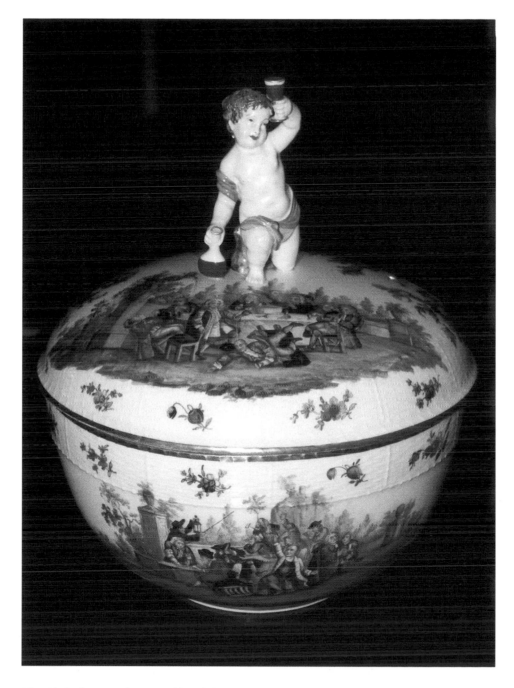

Fig. 48 Berlin porcelain punchbowl decorated with four scenes after Hogarth, *ca.* 1800/1850, John Harvey & Sons, Bristol

Before and After

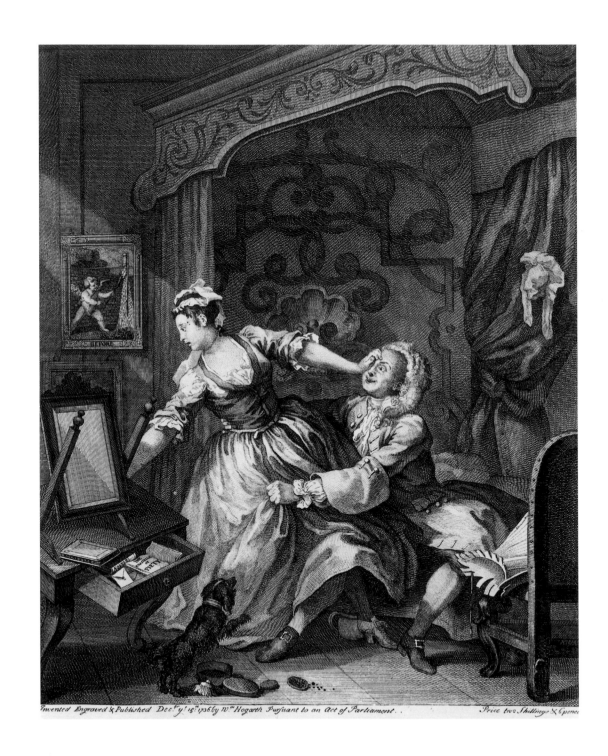

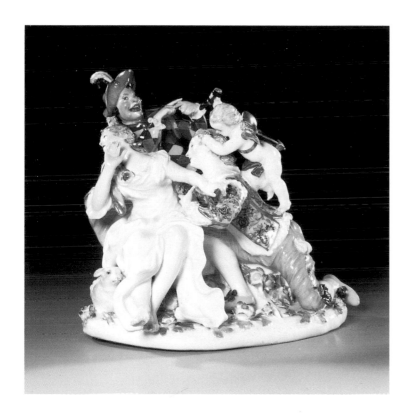

A Meissen porcelain group (left) shows an attitude of gallant ardour assailing female reluctance that is all too familiar. We share in the dog's expression of resignation. Though the pose of the courtship scene seems universal, Dr Menzhausen has drawn a parallel with Hogarth's print, venturing that *Before* inspired Kändler in the creation of this piece.[1] While she observes that the harlequin is Kändler's own invention, she ingeniously derives the Cupid from the small painting of Cupid with his rocket in *Before*.

Even if we accept Menzhausen's thesis of Hogarth as a source, the question still remains whether Kändler worked directly from the image or whether – as with any great artist or composer – it came to him from memory.

LEFT AND RIGHT Figs. 49 and 51 William Hogarth, *Before* and *After*, December 1736, engravings, The Whitworth Art Gallery, Manchester
ABOVE Fig. 50 'Der ungestüme Jüngling und die Schäferin (The impetuous young lover and the shepherdess)', 1740/41, courtesy of Sotheby's, New York

Between April 1736 and May 1737 Hogarth published six prints, including *The Sleeping Congregation* (fig. 61, p. 74), *The Distressed Poet* (p. 13) and a pair, *Before* and *After* (figs. 49 and 51).

In the first picture a young woman strives to escape from her admirer's clutches, hanging on to her dressing table. Both give way, offering Hogarth a neat little joke: in *Before*, just above the falling mirror, we see a picture on the wall of a cherub igniting a rocket firework; in *After*, the companion picture-within-a-picture (previously hidden behind the falling mirror) exposes the rocket as having failed – a clear comment on the 'performance' of the impetuous lover.

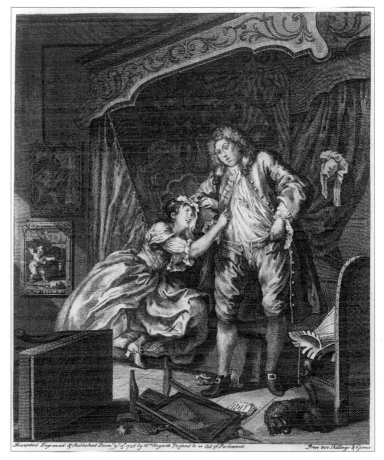

The Four Times of Day

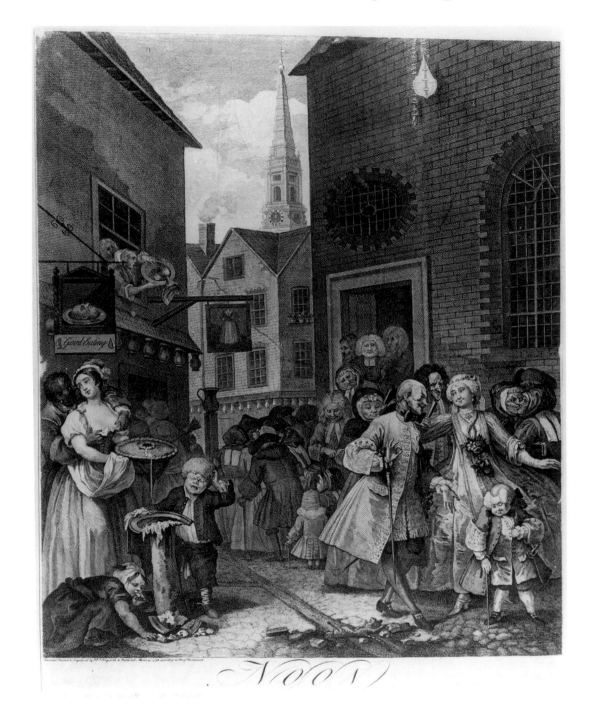

The series of paintings *The Four Times of Day* from which prints were made was commissioned for Jonathan Tyers's Vauxhall Gardens, which Hogarth helped Tyers to establish. In addition to providing pleasant walks and musical entertainment (see fig. 98a, p. 110) one could also partake of food in the special dining boxes where, at a certain hour as one supped, shutters would be drawn aside to reveal Vauxhall's specially commissioned paintings. In his four paintings Hogarth parodies the various entertainments of the day: in *Morning* a spinster looks wistfully at Tom King's rowdy Coffee-House as she passes in the cold to church; in *Noon* we see a congregation spilling out of church with the tavern opposite full of revellers taking in victuals; in *Evening* we follow a family group to Sadler's Wells, a popular spot for those not able to afford Vauxhall Gardens; and in *Night* we encounter a Freemason struggling home after a meeting at the Lodge, aided by his lantern bearer and oblivious to a toppled and burning stage coach behind them.

A number of elements in *Noon* have ceramic resonances: for example, the young boy in the foreground cries after breaking the dish in which he was carrying his pie. The dish is large, with a wide everted rim. On account of its size it seems likely that it is a very plain example of a lead-glazed earthenware baking dish, a type associated with the slipware tradition of South Staffordshire (see fig. 53).

The otherwise standard slipware dish shown in fig. 53 is marked not only with its maker's name and place of manufacture, but it is cryptically dated also, the hand pointing to a small aperture box marked *17* under the numeral *12*, i.e. '1712'.[2] The majority of lead-glazed earthenware, used for everday wares, would be far less ornate.

The Caughley factory, established in 1772, was only a few miles upstream from Worcester, the factory the wares and techniques of which Caughley unashamedly set out to

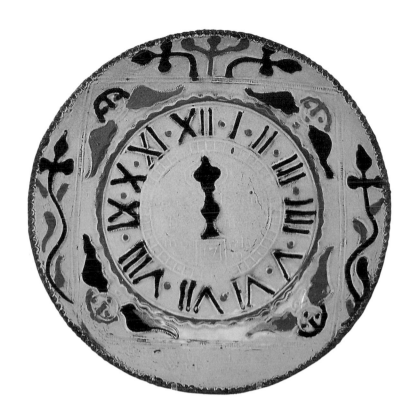

Fig. 53 Staffordshire slipware press-moulded clock-face dish decorated by Samuel Malkin, 1712, private collection

LEFT Fig. 52 William Hogarth, *The Four Times of Day: Noon*, May 1738, engraving, Witt Library, London

Fig. 54 Caughley porcelain mug painted and signed by Fidèle Duvivier, *ca.* 1792, courtesy of Sotheby's, New York

copy. However, many original creations also came out of his factory. Fig. 54 shows an example of the work of Fidèle Duvivier, an exceptional porcelain painter. He seems to have worked at a number of factories including Derby, Wedgwood and New Hall. Pieces from other factories bearing his signature may indicate work done as an outside decorator.[3]

The present piece perpetuates an old joke used by Hogarth in *Noon*, namely the inn-sign of taverns styled 'The Good [*i.e.* headless] Woman'.

Prints provided a regular source for porcelain figure modellers both in England and abroad. The pair seen opposite in fig. 55 are modelled in the manner of such series as the *Cries of London* and the *Cris de Paris*. However, the resemblance of the young woman to the maid in *Noon* is probably fortuitous.

They were made by the 'Girl-in-a-Swing' factory, which takes its name from a figure of the same subject in the Victoria and Albert Museum. It is thought to have been formed by a group of disaffected workers from Nicholas Sprimont's Chelsea Porcelain Factory, some time around 1750.[4]

The eighteenth-century genre remained popular well into the late nineteenth century when the Royal Worcester and Minton factories both issued figures with 'Hogarth' titles, the Minton 'Hogarth Matchgirl' (fig. 6, p. 20) again echoing the maid in *Noon*.

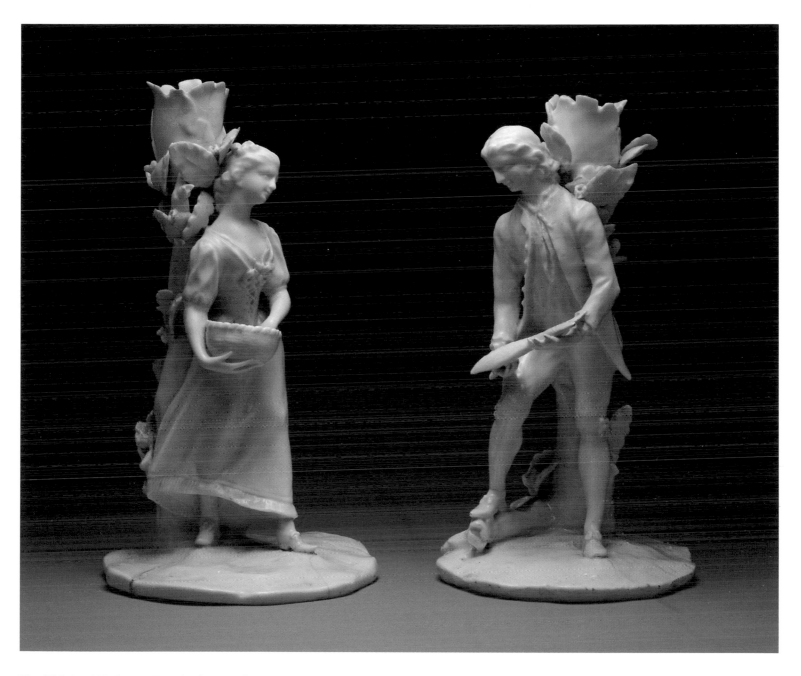

Fig. 55 Pair of 'Girl-in-a-Swing' white candlestick figures, *ca.* 1750, Brian Haughton Antiques

EVENING

Le soir

Fig. 56 William Hogarth, *The Four Times of Day: Evening*, May 1738, engraving, Witt Library, London

Fig. 57 Berlin porcelain punchbowl decorated with *Evening*, nineteenth-century, private collection

Evening

This print proved popular with the decorators at the Berlin porcelain factory and was often used on nineteenth-century punchbowls, as illustrated by the lid of the Berlin punch-bowl shown above. The bowl carries three other scenes from interiors found in *The Rake's Progress*, *A Midnight Modern Conversation* and *Industry and Idleness*. The decorator has given them an *al fresco* setting more attuned to the white porcelain background.

The family group is dominated by the formidable mother who has passed the baby to her tired husband, caught by Hogarth as he passes before a cow whose horns momentarily appear to sprout from his head, suggesting he has been cuckolded.

Fig. 58 William Hogarth, *The Four Times of Day: Night*, May 1738, engraving, Witt Library, London

Night

Oblivious to the disastrous goings-on outside, the barber continues to shave his client, firmly gripping him by the nose as the cut-throat bears down on his chin. A notice outside advertises the barber's parallel trade of tooth puller and surgeon: *Shaving, Bleeding and Teeth Drawn with a Touch, ecce signum* (at this sign). A little rank of bleeding bowls stands at the ready on the ledge outside. It was believed that most major ailments were curable by the tapping off of blood, relieving the patient of his poisons.

With its Scottish and Jacobite symbolism the bleeding bowl (fig. 59) might equally have been intended for porridge. The small, one-handled bowl is common in silver (note the flat tab handle on the present piece, derived from the equivalent shape in metal) and the type is still known in America as a 'porringer'. Nevertheless, as the surgeon-barber's ledge in *Night* clearly shows us, this vessel was a preferred form for the letting of blood.

The figures of the parson guided home by his clerk in fig. 60 must have been inspired by those in the foreground of *Night* where, as we see from his regalia, the master is not a parson but a Freemason.[4] The jaunty angle of his tricorn hat is echoed in the pottery figure. Looking at the facial features in the print, however, the Freemason is gaunt, his eyes are screwed up and his mouth is contorted in the manner of a drunkard attempting to sing. These are exactly the facial features found in the clerk of the pottery group while the parson has a plump face, accentuated by a well rounded wig, not unlike the porcine features of the lantern-bearer.

The Parson and his Clerk remained a popular group in Staffordshire for over a hundred years.[6]

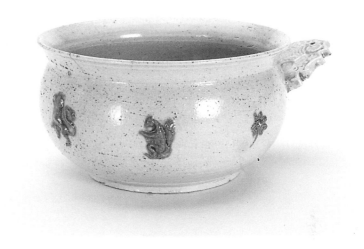

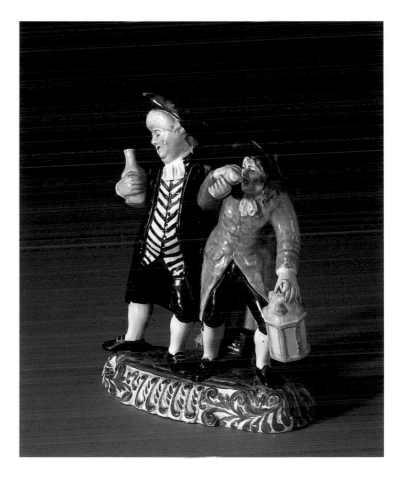

ABOVE RIGHT Fig. 59 Saltglaze bleeding bowl, *ca.* 1760, courtesy of Sotheby's, London

BELOW RIGHT Fig. 60 *The Parson and his Clerk*, Staffordshire creamware group, *ca*, 1760, Royal Pavilion Art Gallery, Brighton

The Sleeping Congregation

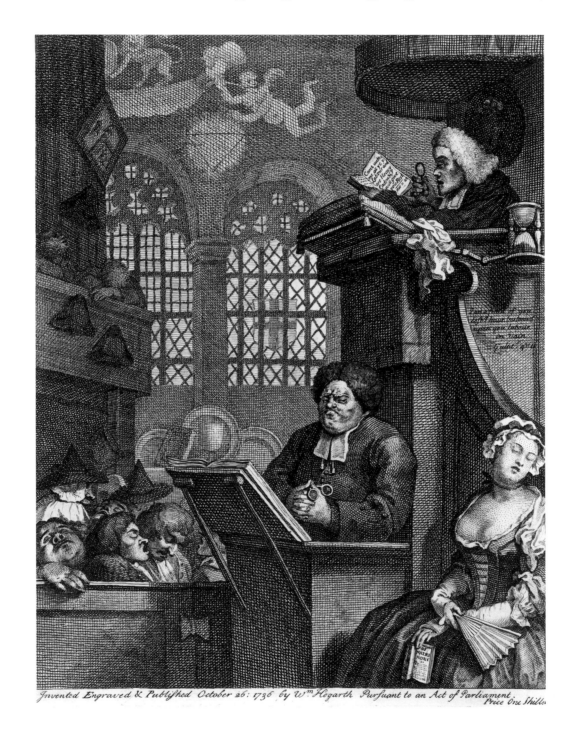

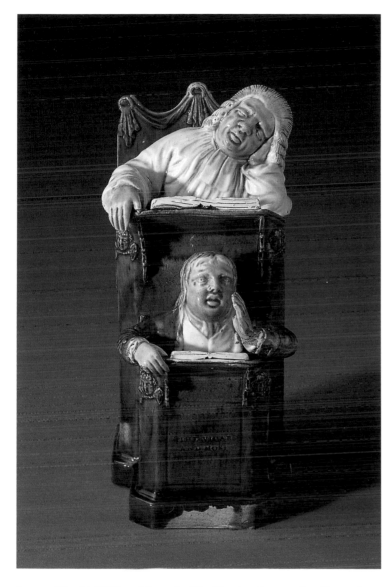

Another parson, another clerk. The preacher in the upper pulpit reads from a text, Matthew 11:28, "… and I shall give you rest", his words borne out by the congregation and the long-since expired grains of sand in the hourglass. Meanwhile, the clerk below him has managed to remain awake, his attention sustained by the sight of his pretty neighbour.

Is the Staffordshire creamware *Vicar and Moses* (left) merely a coincidence of situation or directly inspired by Hogarth's composition? The setting of a double pulpit and the joke of a sermon fervently delivered to a sleeping audience repeats in clay what Hogarth had done on canvas and in the related engraving. The protagonists' rôles transposed (compare the reversal of the parson and the clerk in fig. 60, p. 73), this time it is the vicar's turn to sleep as the clerk preaches.

The creamware is traditionally attributed to a member of the Wood family. It is interesting to note that the same Staffordshire family is also generally credited with the equestrian group of *Hudibras*, an undoubted Hogarthian subject (see fig. 64, overleaf).

Just as *A Midnight Modern Conversation* remained a popular motif on punch-drinking vessels, so *The Vicar and Moses* continued to be manufactured into the nineteenth century, sustained, no doubt, by the ability of preachers and speakers everywhere to drive their audience to slumber.

Following the trend for more and more colour, the earlier in-coloured creamware groups gradually gave way to on-glazed enamel versions. One also sees late nineteenth-century Dutch tin-glazed and even Continental porcelain copies.

Hudibras

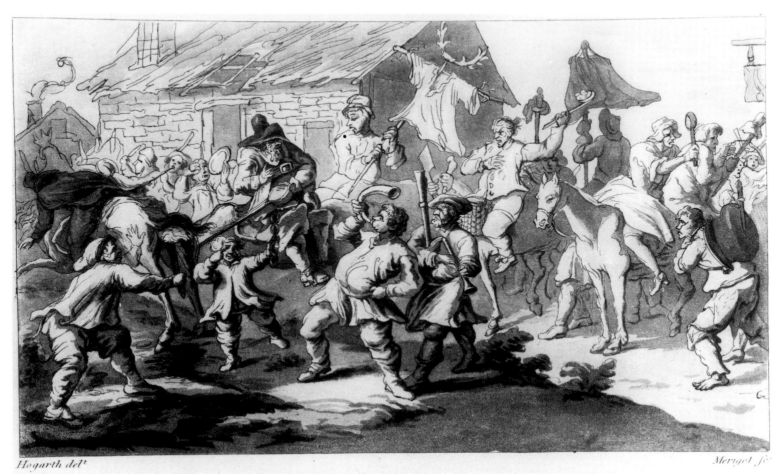

Hogarth del. Merigot sc.

Hudibras encounters the Skimington

Pub for S Ireland May 1 1799

ock-heroic poems formed Hogarth's literary landscape. His own father was a teacher of Greek and Latin, so that Hogarth would have been well versed in the many poets – Butler, Dryden, Pope – who wrote in an ironic style, where classics were constantly juxtaposed with contemporary events. This combination of narrative and irony almost defines his 'Progresses'.

Fig. 63 is one of a set of twelve large prints illustrating Samuel Butler's mock-heroic poem, *Hudibras*, originally published in instalments between 1662 and 1678 – twenty or so years before Hogarth's birth.

This superbly modelled figure (right) is almost certainly derived from Hogarth's large illustrations of Butler's spoof epic. The mock-hero, an English version of Cervantes's Don Quixote, is shown at a village 'skimmington' – an annual event where nagging wives and hen-pecked husbands were tied back-to-back on a horse and paraded round the village to their humiliation but general hilarity.

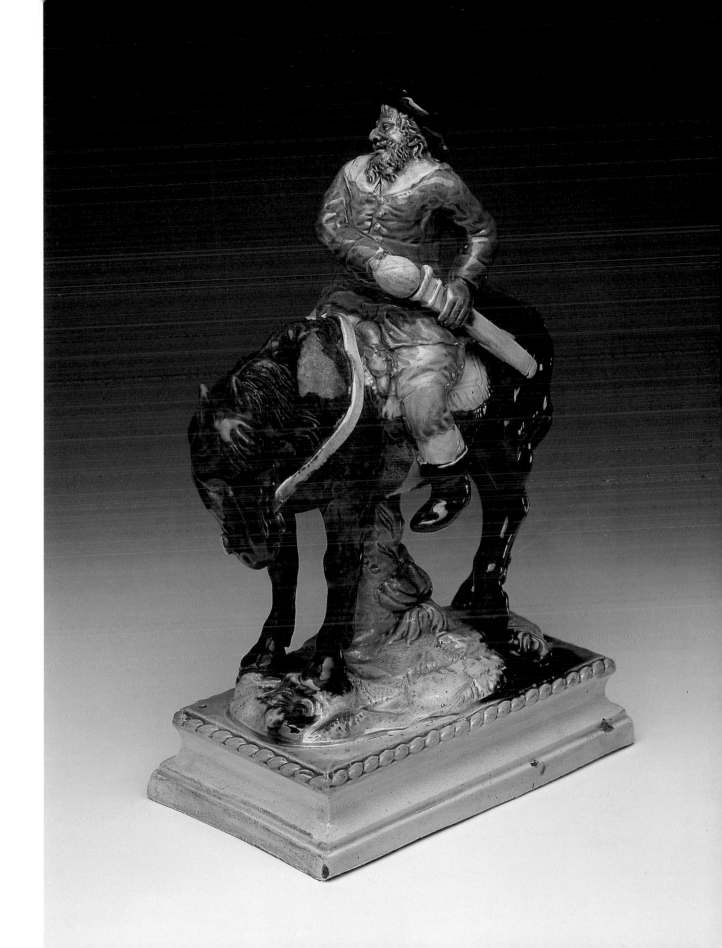

LEFT Fig. 63 William Hogarth, *Hudibras and the Skimmington*, before April 1726, engraving, The Whitworth Art Gallery, Manchester

RIGHT Fig. 64 *Hudibras*, Wood family equestrian group, late eighteenth-century, private collection

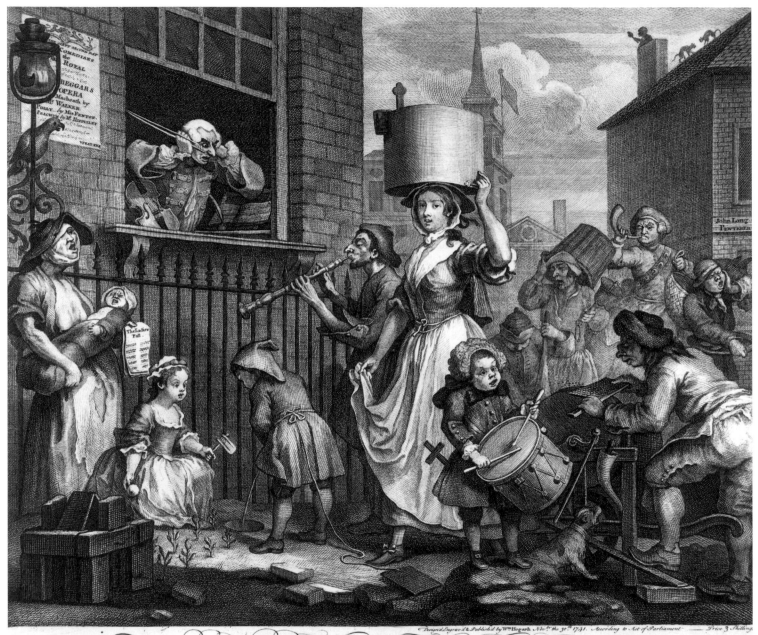

THE ENRAGED MUSICIAN.

This is the noisiest image of the eighteenth century. Reading from left to right we begin to understand the despair of the musician who, because of the intolerable din, has thrown open the window to protest. Outside he finds a squawking parrot, a screaming baby in the arms of a ballad-sheet seller who sings her wares against a travelling oboist, a lad competing on his drum against the scrapings of a knife-grinder; behind them a fish-seller with her bell, and other tradesmen including a pig-gelder (a particularly noisy profession). The flag by the spire announces a saint's day and we may assume the bells are ringing while from the open window of 'John Lang, Pewterer' comes repetitive tapping mixed with sounds of cats wauling on a neighbouring roof. The only hope of silence is offered by the little girl who, for a moment, is speechless, her rattle frozen, as a boy stops to pee on the ground before her very eyes. Through the centre of this cacophony, crying her wares, steps the milkmaid.

Several of Robert Hancock's many images engraved for transfer-printing on to Worcester and other porcelains from 1757 onwards[1] contain scenes of milkmaids. Of these the print known as *The Milkmaids* invites comparison with Hogarth's *Enraged Musician* in that one of the two maids adopts a similar attitude, facing the viewer, steadying her pail with one arm raised, while her other hand rests on her hip.[2] Hogarth's maid actually lifts the hem of her skirt as she steps out.

We have already seen in the *Harlot* series an instance of a single element – the astonished black boy – being lifted out of the original image and dropped, complete with expression of surprise, in an altogether calmer setting (see fig. 23,

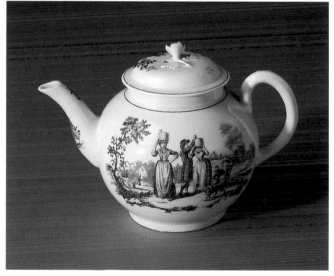

LEFT Fig. 65 William Hogarth, *The Enraged Musician*, November 1741, engraving, The Whitworth Art Gallery, Manchester
ABOVE RIGHT Fig. 66 Longton Hall porcelain figure of a milkmaid, *ca* 1755, private collection
BELOW RIGHT Fig. 67 Worcester porcelain teapot, decorated with *Milkmaids*, *ca*. 1765, Royal Pavilion Art Gallery, Brighton

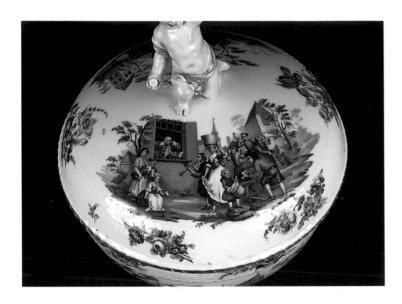

Fig. 68 Berlin porcelain punchbowl, nineteenth-century, private collection

p. 39). Having established one example of a Hogarth source adapted through an intermediate route, one would be surprised to find no more. A similar route seems to have been taken by the milkmaid.[3]

The Longton Hall factory in Staffordshire was one of the earliest English porcelain factories, founded in *ca*. 1750. If the milkmaid shown in fig. 66 (previous page) was made in 1755 it would antedate Robert Hancock's employment at Worcester by a couple of years.[4] It seems entirely reasonable to suggest a link with the Hogarth print given the similarity of the figures; note the hem of her apron, gathered in one hand, as well as the actual 'stepping forth' pose of the feet.

Fig. 69 Chinese export porcelain saucer, decorated with *Milkmaids*, 1760s, private collection

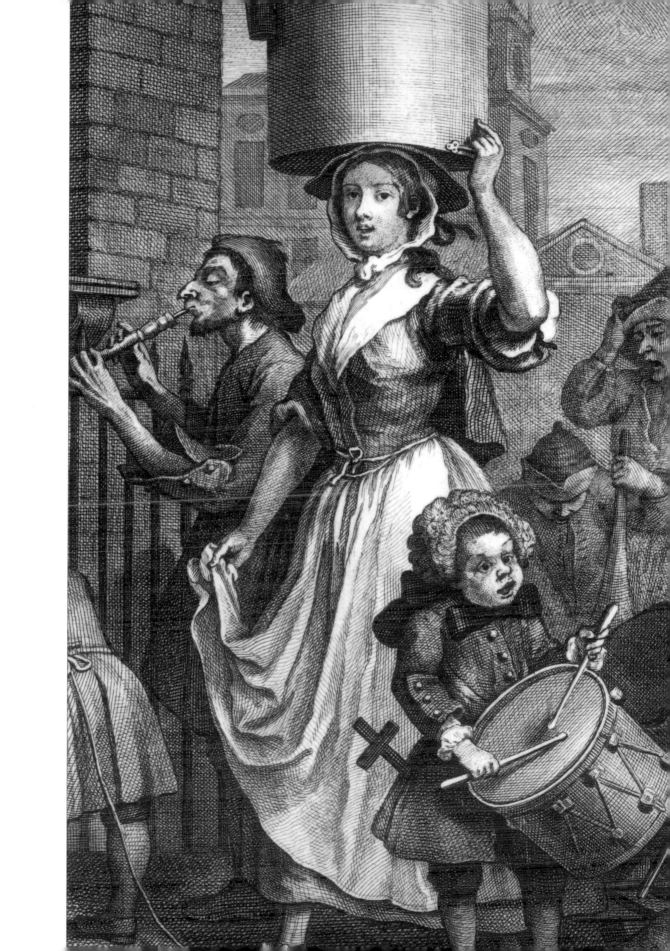

Detail of fig. 65, p. 78

Marriage à la Mode

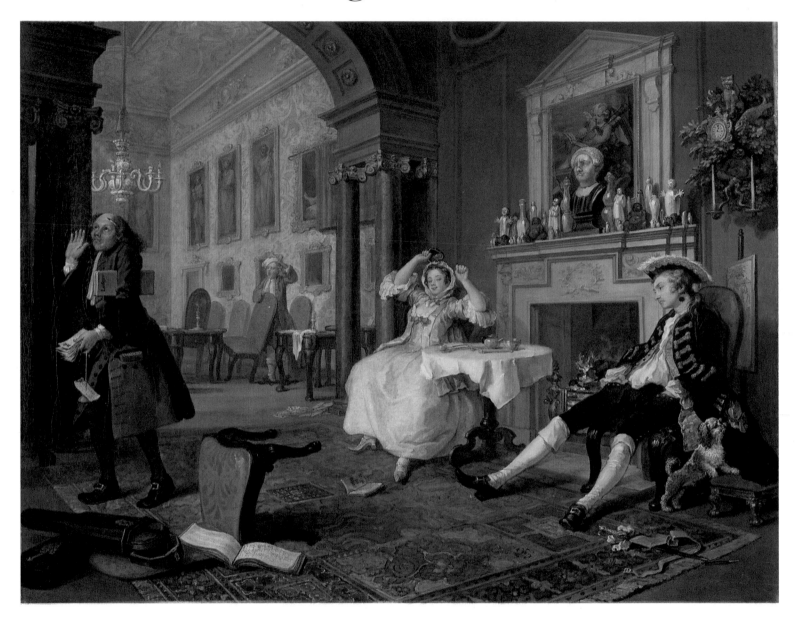

Fig. 70 William Hogarth, *Marriage à la Mode II: The breakfast scene*, 1743/44, The National Gallery, London

This is undoubtedly Hogarth's finest series, successfully melding realism with symbolism. The story follows the consequences of impoverished pedigree marrying *nouveau riche*, an arranged alliance in which each party hopes the other will repair its own deficiencies – fortune bartered for character. Far from complementary, these opposites, devoid of love or attraction, bring destruction.

In the first scene Earl Squanderfield proudly declaims his lineage from William the Conqueror while the lawyer pays court to a bride ignored by her groom. Scene II (opposite) finds the couple leading separate lives, she flushed from a night of riotous company, he returned from some other scene of dissipation, his adventure sniffed out by the dog. In the third picture (fig. 73, p. 86) the Earl, having infected his under-age lover, lightheartedly brings her to the quack for treatment. Scene IV (fig. 75, p. 88) attends the newly elevated countess at her levée with the froth of London society swooning to the unmanly voice of a bovine castrato singer.[1] In the penultimate scene, having caught his wife and his lawyer *in flagrante*, the young Earl is mortally wounded following a duel; the lawyer is apprehended and hanged. The last scene (fig. 77, p. 90) shows the Countess having taken her own life with laudanum after reading of her lover's execution.

Like all the authors of great tragedies Hogarth sustains our interest over all six acts by bringing together a series of unexpected turns. Each picture is independent but all are united by a forward momentum of menace, our forebodings distracted by occasional comic detail. Catharsis occurs with the sacrifice of the Earl, killed at the one point where he seizes the opportunity to redeem his situation. With his death the weight of the previous images brings death to the Countess. Her marriage, having commenced in the overbearing pomp of gout-inflated aristocracy, ends in the honest surroundings of the modest merchant house from which she originally came.

Of the many symbolic props used by Hogarth throughout his interiors, paintings are the most loquacious. This is hardly surprising for an artist with strong and outspoken views on the merits and deficiencies of different schools, particularly foreign ones. Also, like the rooms themselves, walls needed his painted decorating, so why not use images which correspond to the situation? Thus in the opening scene of *Marriage à la Mode* Hogarth leads us through an aristocratic gallery of pompous images intended by the owner to inspire awe but, nudged by subtle caricature, they stimulate irony and we are manipulated into Hogarth's own hardened view. In the next image, *The breakfast scene* (opposite), exactly the same is done using ceramics. In addition to a gallery where apostles hang cheek by jowl with a (covered) pornographic painting, the young couple (her money united with his taste) have become connoisseurs of fine porcelain. Though the tea table carries modest pieces of Chinese porcelain, behind them glimmers a fireplace piled, seemingly, with fashionable *blanc de Chine* porcelain. However, as with the Earl's paintings, Hogarth has taken liberties. He has taken real objects – porcelain vases, figures, bottles and knick-knacks – and pushed them into surreal absurdity, compromising their owners.

One's first scan of the shelf reveals a predominance of white pieces, almost certainly *blanc de Chine*, and among these we see a pair of figures with large, outstretched hands. These correspond to no known ceramic figure or artefact, they are pure fantasy. Reaching wide they seem to be gesturing that husband and wife are worlds apart, that the gap is widening. The gulf between them is further stressed by their standing at opposite ends of the mantelpiece. Their hand gestures echo the steward's own heavenward surrender: 'Where will it all end?' The remaining white pieces are far closer to conventional ceramic forms. Amongst them a crowd of miniature vases – some perhaps Chinese snuff bottles. To complete this exotic, oriental landscape Hogarth has dropped in a pair of green frogs as well as a pair of *magot* figures – little *chinoiserie* pot-bellied Buddhas made of a

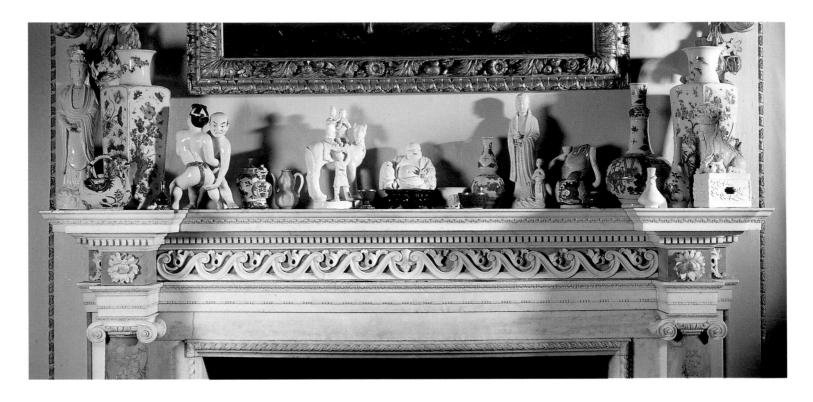

Fig. 71 A group of mid to late seventeenth-century Chinese and Japanese porcelains made for the European market, including several pieces of *blanc de Chine* – a number of which correspond to entries in the two seventeenth-century Burghley inventories (1688 and 1690), including '1 ball'd fryor' (centre), Burghley House, Lincolnshire

brown clay. These are almost certainly examples of Chinese Yixing stoneware, the same material used for early imports of Chinese teapots (see fig. 11, p. 24). Another possibility would be very early Meissen Böttger ware – though whether Hogarth would have seen any is questionable. A third such Buddha lurks in the branches of the wall-light which also contains a fish, a clock and a cat. It is a tribute to the artist that he is able to insert the surreal without undermining the powerful realism of the flesh-and-blood characters seated at the table.

The English mantelpiece has always been the heart of the home, a place where the family gathers and visitors are received. As the focal point of a room, its shelf becomes a stage upon which the owner displays his taste and treasures,

a mini altar devoted to his particular household gods. In the seventeenth century, after increasing contact with China and Japan, it had become fashionable to display the wide scope of one's taste and wealth by cramming mantelpieces with oriental porcelains. Corner fireplaces in state rooms offered ideal opportunities for a pyramid of steps ascending to the cornice or ceiling, crammed with the porcelains of China and Japan.[2] To fill these china terraces orders were placed for *garnitures de cheminée* – sets of vases specifically made for this purpose, usually numbering five. Burghley House in Lincolnshire has a number of such corner fireplaces, where many of the Japanese and Chinese porcelains still exist and can be identified (and therefore dated) from two inventories taken in 1688 and 1690.

Fig. 72 A group of *blanc de Chine* pieces from Burghley House, Lincolnshire

Marriage A-la-Mode, (Plate III)

Invented Painted & Published by W.ᵐ Hogarth

Engraved by B. Baron

According to Act of Parliament. April 1ˢᵗ 1745

Fig. 73 William Hogarth, *Marriage à la Mode III: The scene with the quack*, June 1745, engraved by B. Baron, The Whitworth Art Gallery, Manchester

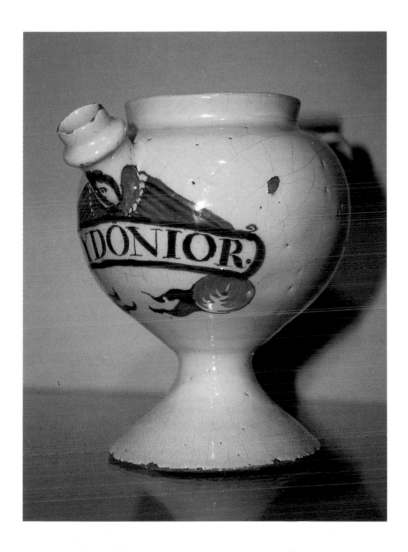

Fig. 74 English delftware drug-jar, 1740s, private collection

The third picture in the *Marriage à la Mode* series, *The scene with the quack*, mixes a museum of curiosities with the utensils of the apothecary trade.[3] The shelves beside the skull are filled with real ceramics, the delftware wet and dry drug-jars containing a variety of traditional remedies ready for dispensing. Unlike the ceramics in *The breakfast scene* they are among the only everyday objects in the room. In this shop of horrors, with its nightmare machines for lifting bodies and straightening limbs, Hogarth offers us few other lifelines to reality. The viscount's playful gesture and bravado betoken an ignorance of his surroundings.

All the English delftware factories produced ceramics for private and public apothecaries. Lambeth kilns are particularly noted for the variety and quality of their dry and wet storage jars. By far the majority were blue-and-white and the standard decoration was an ornamental label within a frame of cherubs or flowers. Though the domestic delftware industry was destroyed by the innovations of the other English ceramic industries (porcelain, creamware, transfer-printing), a number of factories continued making pharmaceutical wares – vessels for ointment and salves – into the early nineteenth century before folding (see fig. 74, left).

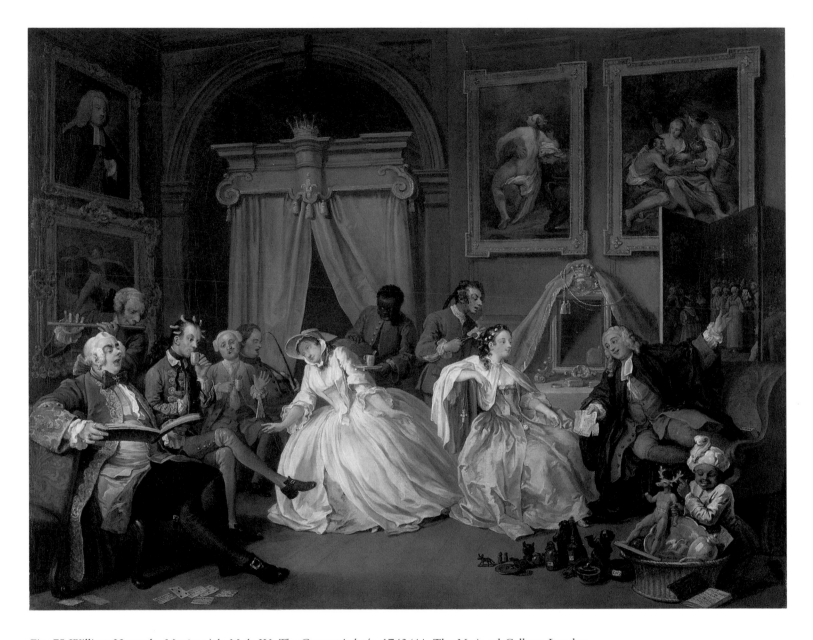

Fig. 75 William Hogarth, *Marriage à la Mode IV: The Countess's levée*, 1743/44, The National Gallery, London

The fourth picture in the *Marriage* series, *The Countess's levée*, shows her passion for collecting unabated. In the foreground the little black page – complete with plume and turban, seen in *A Harlot's Progress II* (see fig. 21, p. 25) and *Taste in High Life* (fig. 79, p. 92) – unpacks a basket laden with the latest trophies bought at auction. On the floor we see miscellaneous bronzes, antiquities and other knick-knacks while in the basket remains a lidded jar (probably Chinese), a terracotta figure of Actaeon and a tantalizing glimpse of a lobed dish depicting the legend of Leda and the Swan. It is coloured and the rim is chipped: it must therefore almost certainly be a piece of tin-glazed earthen-ware, probably Italian maiolica of a type produced at Urbino and known to eighteenth-century English collec-tors as 'Raphael ware'.

Furthermore, as the company is treated to the delicious song of the castrato, a second black servant brings them coffee in long Chinese porcelain cups, each accompanied by a wafer.

Fig. 76 Meissen porcelain chocolate cup and saucer, 1740s, courtesy of Christie's, London

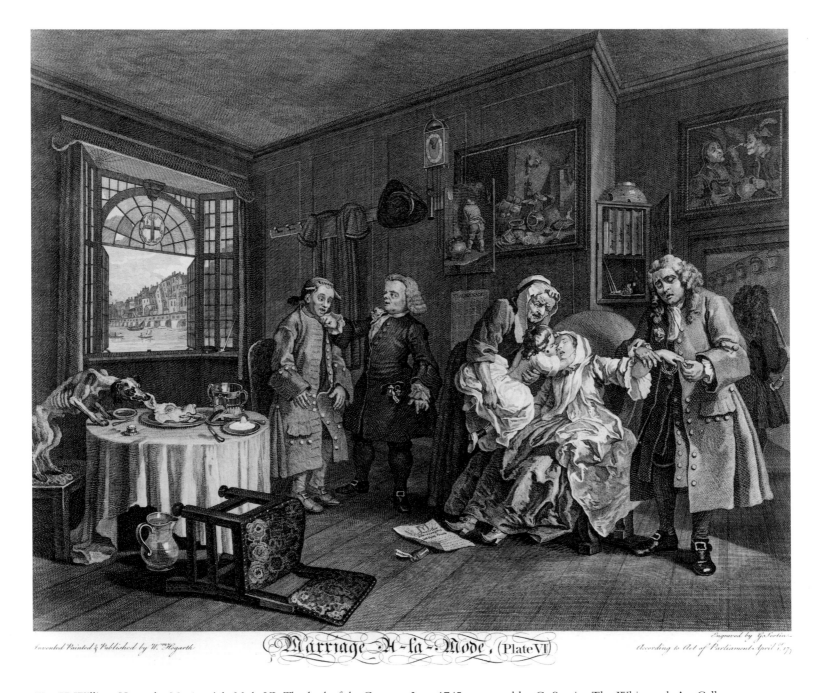

Fig. 77 William Hogarth, *Marriage à la Mode VI: The death of the Countess*, June 1745, engraved by G. Scotin, The Whitworth Art Gallery, Manchester

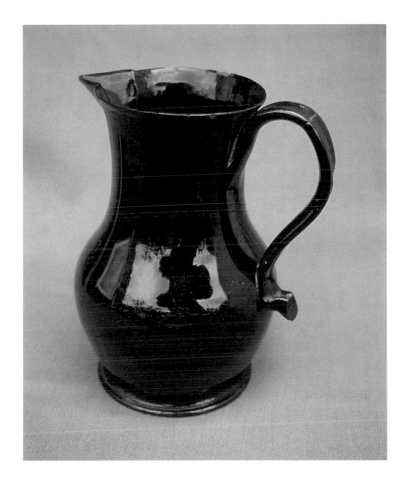

Fig. 78 Salt-glaze stoneware jug, 1740s, private collection

Finally, in the suicide scene, we find the Countess restored to her original merchant milieu. Gone are the pretentious trappings of fashionable collectables. The Dutch paintings on the wall show a jumble of coarse ceramics for coarse drinking while the familiar sight of an upturned, broken punchbowl on the corner cupboard emphasizes the destruction. From its form, handle and colour, the large jug on the floor beside the table does not appear to be metallic; it is either of fine white stoneware (for which it is large) or of delftware (see fig. 78, left). In it we see the silhouette of a shadowy figure. Perhaps of the artist himself?

Taste in High Life

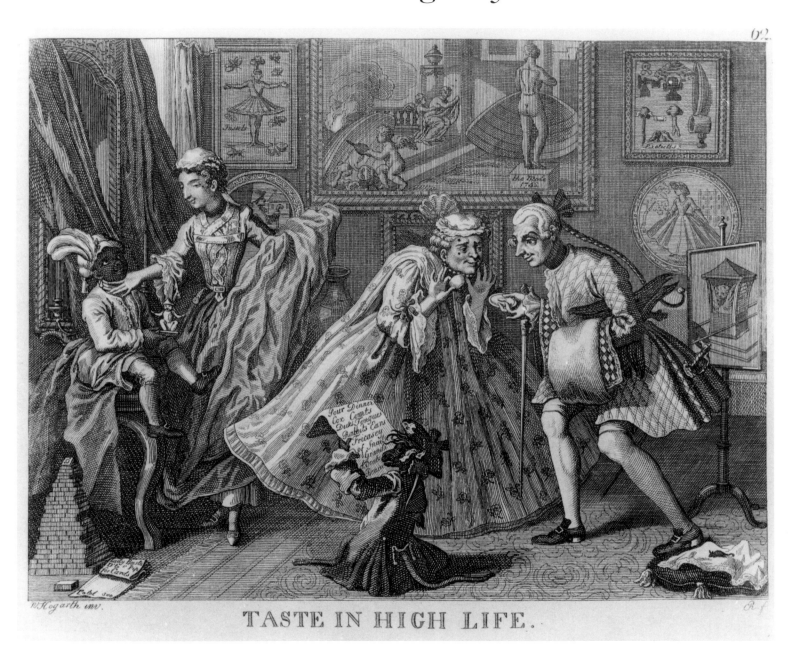

Fig. 79 William Hogarth, *Taste in High Life*, May 1746, engraver unknown, Witt Library, London

With porcelain worship at a peak among the aristocracy as well as the increasingly wealthy merchant classes, Hogarth once more hits the mark. Mary Edwards, one of Hogarth's patrons, commissioned him to paint *Taste in High Life* at a time when his ideas for *Marriage à la Mode* were beginning to come together. As a response to jibes against her own conservative tastes she asked Hogarth to produce an image lampooning the *dernier cri* of French-inspired taste. In it we find two elements already used ten years earlier in the *Harlot* – the little black page in his plumed turban and the pet monkey seated on the floor.[1]

At the centre of the picture appears a dandified couple wearing caricature costumes of which the exaggerated elements – destroying all decorum – are wholly out of step with their years. All the elements are scientifically dissected in the prints and paintings on the wall behind – the lady's wide crinoline skirt, the man's butterfly bow, his plaited Chinese pigtail and muff. The couple are caught in the act of worshipping a dainty morsel of Chinese porcelain, its tiny size rendered even more absurd by the puffed-up dimensions of the connoisseurs' costumes. Their mincing hand postures echo a third element from *Harlot II* (fig. 21, p. 35), the merchant's careful holding of cup and saucer. Painted eleven years after the *Harlot* engravings were published, the image had remained popular and would have been in the forefront of Hogarth's memory.[2]

Graced by a large porcelain vase in the background, the picture is a remarkable preview of the even more virulent China Mania which once again was to rage through Europe over one hundred years later (see fig. 8, p. 21).

Spurred on by the clamour for china, the first English porcelain factories finally appeared in the 1740s at Bow (1744), Chelsea (*ca.* 1745), Derby (*ca.* 1745), Bristol/Worcester (1752), Longton Hall (*ca.* 1750).

Published in 1746, the anonymous engraving, unauthorized by Hogarth, could not have been more timely.

Hogarth, Garrick and the Drury Lane Theatre

Fig. 80 Subscription ticket to William Hogarth's 1746 engraving of *Garrick*, shown opposite

The Bearer hereof is Intitled to a Print twenty Inches by 15 and an half, of M.ʳ Garrick, in the Character of Richard the Third, Engraved after a Picture Painted By M.ʳ Hogarth

Famous for his Shakespearean rôles, David Garrick (1717–1779) was universally regarded as the greatest actor of his day, dominating the London stage for forty years. With Hogarth's own love of Shakespeare and his interest in character and drama – both on stage and in the world at large[1] – the two men were bound to converge.[2] Garrick had originally been destined for the wine trade but was encouraged to write by his teacher Samuel Johnson. After a number of articles in *The Gentleman's Magazine*, his play *Lethe* was performed at the Drury Lane Theatre in 1740 and was an instant success. In 1741 he took London by storm in his performance of *Richard III*.[3] Two years later – aged only thirty, when Hogarth was fifty – he bought a half share in the Drury Lane Theatre, where he remained as actor manager until retiring in 1776. In a turbulent, even dangerous profession it was a meteoric rise which brought him into contact with all the notable actors and actresses of his day – Margaret 'Peg' Woffington, his sometime mistress, Kitty Clive and Henry Woodward (from 1749 both performers in a revised version of his earlier success, *Lethe*[4]) and the fiery James Quin.

At a time when performances of the Bard were far from committed to accuracy of text or plot, a large part of Garrick's fame was based on his revivals of Shakespeare. To cater for the tastes and sensibilities of the day, the plot of a play was often considerably 'improved' with cuts and additions, giving the actor some room for personal manœuvre. Despite his own such tamperings, Garrick's flair did much to bring Shakespeare to the centre of the British stage. Aided by the widely circulated print of his painting, Hogarth's first portrait of *Garrick in the character of Richard III* (see fig. 81, opposite) gained a status beyond that of a

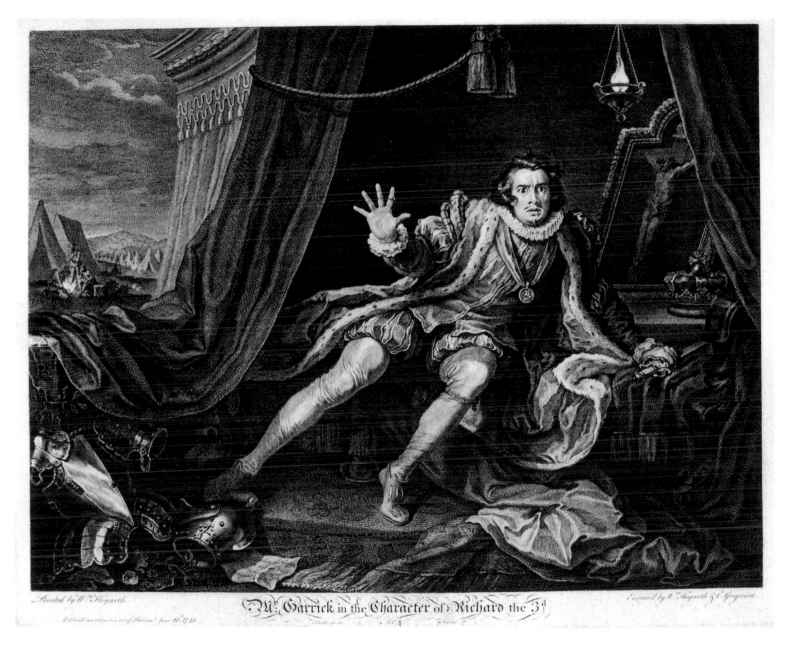

Mr. Garrick, in the Character of: Richard the 3d.

Fig. 81 William Hogarth, *Garrick in the character of Richard III*, July 1746, engraved by Hogarth and C. Grignion, Royal Pavilion Art Gallery, Brighton

portrait of a famous actor; it became the standard image of Shakespeare's notorious tyrant. That a Staffordshire potter should reinterpret Hogarth's image as an inexpensive 'flat-back' pottery figure one hundred years later (see fig. 7, p. 20) was as much a tribute to Garrick as to Hogarth's depiction of an elemental Shakespearean rogue. Nevertheless, it unmistakeably preserves Garrick's features, frozen in the attitude of horror as he is faced with a bloody procession of his past victims. His hand thrust out in a gesture of aversion was a stock pose in the eighteenth-century actor's armoury, and one echoed in a later Derby figure where Garrick is depicted standing.[5]

Sixteen years later, in 1757, Hogarth again painted Garrick, this time attended by his wife, the dancer Eva Maria Veigel. He is depicted sitting in the chair designed for him a year earlier by Hogarth for his presidency of the Shakespeare Club.[6] For reasons of composition the trophies of Music and Drama which crown the original chair – incorporating a scroll and a theatre mask with the recognizable features of Garrick – have been omitted. These same trophy elements occur not only on Hogarth's original 1745 subscription ticket to the Richard III print (see fig. 80, p. 94), they are also echoed in the trophies of Art on the moulded bases of some Bow versions of *Kitty Clive* (*ca.* 1750). Thus Hogarth's theatrical and artistic connections link him, if indirectly, with some of the individuals responsible for the creation of new porcelain factories. The artistic community of London in the 1740s was closely knit within its inner structure of Huguenot craftsmen, artists such as Roubiliac (see pp. 6–7) and Sprimont. (Garrick himself was in part Huguenot.) But as we know from his swipes at china connoisseurs, Hogarth was no dedicated follower of porcelain, much less a conscious designer.

The later portrait was presented to the Garricks by Hogarth's widow in 1764. Two years later, in their prologue to *The Clandestine Marriage*, Garrick and co-author, George Cole, acknowledged their indebtedness to the cast of *Marriage à la Mode*.[7] In 1771, seven years after Hogarth's death, Garrick, conferring with his erstwhile mentor Samuel Johnson, composed the epitaph to be seen on Hogarth's tomb at Chiswick today.[8]

In the Bow porcelain figures of *Kitty Clive and Henry Woodward* (fig. 82), the modeller has captured two striking portraits of living, breathing figures from the mid eighteenth century.

Among the earliest of all English porcelain figures, these examples were instantly copied by other factories, including Chelsea and Derby, in both the white and the coloured versions. Their creation at the very outset of the English porcelain industry points to an overlap of the tastes of porcelain buyers and the London theatre-going public. The English porcelain industry was largely reliant on two major sources of design: the imported porcelains of Meissen, China and Japan, and the forms and shapes of silverware. The creation of what are amongst the largest English portraits ever executed in porcelain is a testament to the verve and competence of a new industry as well as to the actors themselves.

Both figures have been 'translated' from engravings – by Charles Mosley, after a drawing of Clive by Worlidge and by McArdell, after a painting of *Woodward* by Francis Hayman. There is no denying the fact that when compared to the grace and technical competence of Meissen figures, English porcelain is inferior. It could not match that of the great courtly factories of Europe where grand patrons subsidized production so heavily that imperfect pieces could be discarded. In England, where the owners were businessmen hoping to cater for a wealthy bourgeoisie as well as aristocrats, the factories relied on resources simply not on the same princely scale as the Continent. For this reason, and not only the far more experimental nature of the raw materials used (Meissen had discovered the recipe for true hard-paste porcelain while almost all English factories were producing artificial soft-paste porcelain), early English

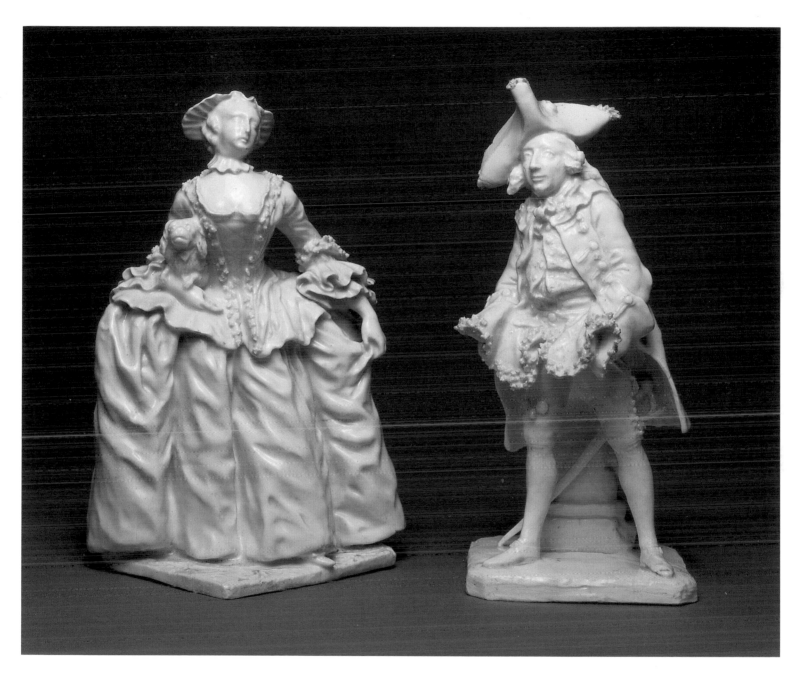

Fig. 82 *Kitty Clive and Henry Woodward*, Pair of Bow white figures, *ca.* 1750, Brian Haughton Antiques, London

Fig. 83 A pair of Bow sphynxes, *ca.* 1750, courtesy of Christie's, London

porcelains are often slightly imperfect or flawed, at least in comparison.

A Bow figure (above) depicts James Quin (1693–1766) in his most famous rôle, Falstaff, a part which he first played in 1720 and which, like Garrick's later Richard III, became a stock performance. The figure captures Quin's skyward glance as the actor declaims to the back of the audience.[9] Both this and a later (1765) Derby figure are based on a print by Grignion after the painting by Hayman at Vauxhall Gardens.

Though a member of Garrick's Masonic lodge (the same lodge to which Hogarth himself belonged), Quin proved less brotherly than Garrick might have hoped. At a time when Garrick's performances of Shakespeare were losing audience to the exotic harlequinades mounted by the opposition at Covent Garden, Quin defected to the other faction, taking with him several of Garrick's cast, including Woffington. However, after Quin's retirement in 1751, the two men once more became friends, Garrick composing Quin's epitaph, which also bore Hogarth's original mask-

ABOVE LEFT Fig. 84 Bow porcelain figures of, left, *James Quin in the rôle of Falstaff, ca.* 1750–52; right, a gentleman, possibly David Garrick, *ca.* 1752, courtesy of Sotheby's, New York
ABOVE RIGHT Fig. 85 William Hogarth, *Portrait of James Quin, ca.* 1745, Tate Gallery, London

and-palette design (see fig. 80, p. 94 and p. 96).

The pair of busty sphinxes shown opposite have well featured female portraits which, since the late nineteenth century, have been identified as Margaret 'Peg' Woffington.[10] Made by Bow in the late 1740s, they are enamelled and gilt in a style very similar to that of the Quin portrait.

The Gate of Calais

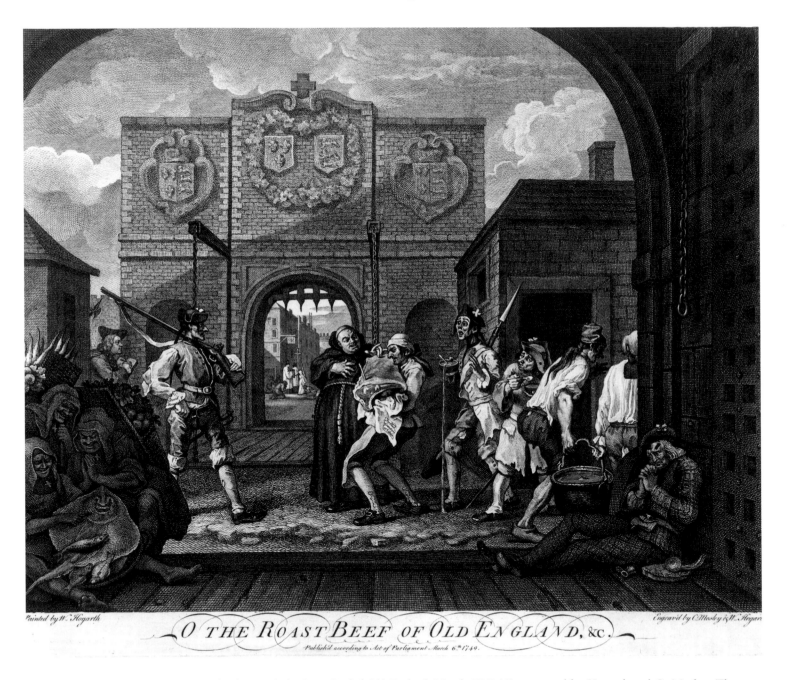

Fig. 86 William Hogarth, *The Gate of Calais* or *O the Roast Beef of Old England*, March 1748/49, engraved by Hogarth and C. Mosley, The Whitworth Art Gallery, Manchester

In 1736, four years before Garrick's *tour de force* as Richard III, Henry Fielding had taken up the management of the New Theatre, Haymarket.

Though from differing backgrounds – Fielding from the landed gentry, Hogarth from the bourgeoisie – the two men were friends, sharing the same sense of outrage at the evils which attended the poor in the metropolis. In 1731, one year after *A Harlot*, Hogarth engraved the frontispiece to Fielding's *Tom Thumb* and together, throughout the 1730s, the plays and images produced by the two men took London by storm. In 1732 Fielding's play *Covent Garden Tragedy* was performed, strongly influenced by the characters and plot of Hogarth's own *Harlot* series. What Hogarth put into paint and engraving, Fielding expressed in words – both men recording and commenting on the vices of the day.[1]

In 1748, Hogarth was fifty years old. During his lifetime England and France had been at war for a total of sixteen years. The strategic and economic rivalries between the two countries were mirrored and magnified by each country's Protestant/Catholic divide. In 1688 England had ousted the Catholic Stuarts and replaced them with Protestant Hanoverians, devolving much of the monarch's absolute power to an elected parliament. In France, meanwhile, Louis XIV had centralized and strengthened his Catholic dynasty, causing many thousands of Protestants to

Fig. 87 Chinese export porcelain punchbowl decorated with *The Gate of Calais* and the arms of Thomas Rumbold, 1750s, Victoria and Albert Museum, London

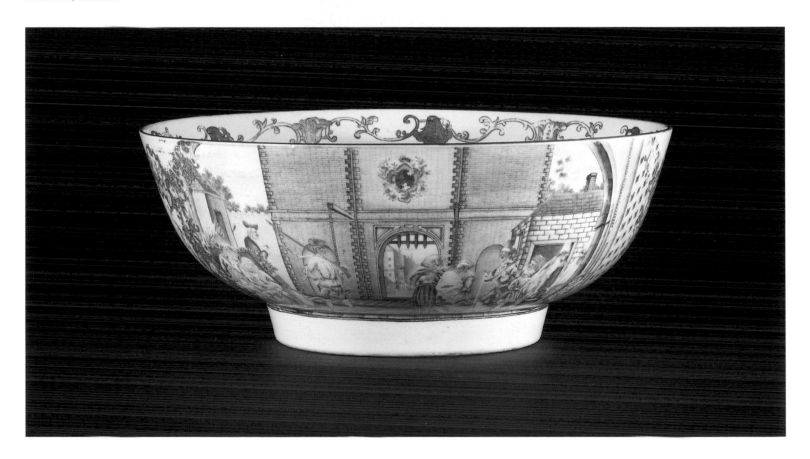

flee after the revocation of the Edict of Nantes in 1685. Thousands of Huguenot refugees came to England, bringing with them the skills which played so large a part in the flowering of the English decorative arts in the late seventeenth and eighteenth centuries. Huguenot stories of expulsion from France can only have magnified Hogarth's antipathy as well as his national sense of unease towards France. Nevertheless, his Huguenot friendships brought him close to the achievements of French Baroque, and many of the engravers Hogarth hired to produce the prints of his works were themselves French.

With this uneasy mixture of attitudes Hogarth and several other painters travelled to France in 1748 during the armistice preceding a conclusion of peace between the two nations. When passing through Calais Hogarth unwisely proceeded to make sketches of the city gate and drawbridge. He was arrested and subsequently expelled on suspicion of espionage, saving his life (according to one account) by demonstrating to his captors his skills of drawing and caricature.

When safely back home he retaliated with *The Gate of Calais*, in which we see an eruption of Hogarth's anti-Gallic prejudices. As a focus for his send-up of the Catholic clergy and their superstitious flock, he fixes on the meagre French *cuisine*, endured by a starved, gullible and enslaved peasantry, contrasted to the massive side of beef, destined

for Madam Grandsire's English eating house, a metaphor for the wholesome fare (spiritual and gastronomic) enjoyed by the free men of England. Deserving his fate, a tartan-clad follower of Bonnie Prince Charlie, a refugee from the 1745 rebellion, is forced to eat the bread of exile.[2]

Top left can be seen the artist himself at the very moment of his arrest, a soldier's hand laid on his shoulder. The print was engraved shortly after the painting and the subtitle *O the Roast Beef of Old England* was taken from Henry Fielding's song of the same title in his *Grub Street Opera* of 1731.

Several Chinese porcelain bowls dating to the 1750s are known bearing a painted version of the popular Hogarth print.[3] The bowl illustrated on the previous page was commissioned for Thomas Rumbold, a servant of the East India Company from 1752. Rumbold's own arms replace the arms recorded on Hogarth's original painting, the arms of England. True to Hogarth's original, however, the artist's self-portrait appears (top left, in a red coat), faithfully copied by the Chinese artist following the coloured print sent out to China.

Commissioned and executed within Hogarth's lifetime, the artist would no doubt have been both amused and flattered to find himself translated into the very material he so often lampooned.

An Election

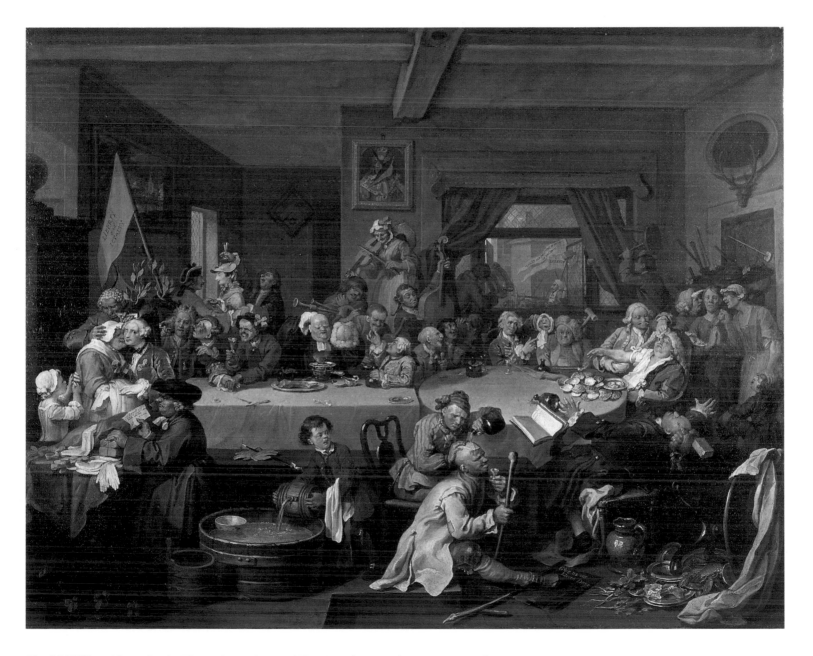

Fig. 88 William Hogarth, *An Election Entertainment*, 1755, Sir John Soane's Museum, London

The Politician.

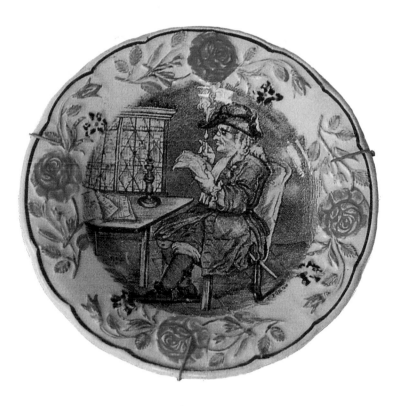

Hogarth's four engravings of his own paintings based on the Oxford election of 1754 were not completed until January 1758, four years after issuing the subscription ticket. Of all his series, these are the largest (each measures approximately 102 cm × 127 cm). In complexity of composition they are the most ambitious and perhaps his greatest technical achievement. They are skilfully painted, seamlessly blending reality and metaphor. In their polished pessimism, however, they diverge from the playful impressionism of the *Rake*. Whereas in the earlier series Hogarth's strength comes from partially enticing us into an enjoyment of the vices which he seeks to condemn, here there is no ambivalence. All is folly. The cynical attitude reflects the hardened Hogarth of later years. The paintings were bought by Garrick to whom their theatrical qualities would have appealed.

This four-part series starts with *An Election Entertainment* (fig. 88, p. 103), a lavish tavern 'treat' by which a political party hoped to secure a string of voters. The table shows a tavern feast in full swing, insults and missiles thrown through the open window by opponents outside. A brick has struck the election agent (bottom right) who reels backwards from the blow. Other less volatile ceramics at this rowdy event include the blue-and-white bowl — almost certainly delftware — floating in a vat of punch; the large jug, beside the unfortunate agent's chair, which appears to be of lead-glazed earthenware; and the small bowl into which the barber surgeon bleeds his swooning client, again apparently of delftware (see fig. 59, p. 73).

The room contains no less than thirty-four people, three times the gathering in *A Modern Midnight Conversation*, too large and complex a composition to appeal *in toto* to a ceramic designer. However, the corpulent Quaker seated reading a note, in the bottom left-hand corner recalls a Hogarth oil sketch of a politician sitting in similar pose, burning his hat as he reads. Believed to date to the 1750s, this image was later engraved and became the source for a canary-yellow plate manufactured in the 1830s (fig. 90).[1]

Hogarth and Wilkes

In 1763 John Wilkes (1727–1797), Member of Parliament for Aylesbury, was summoned before the Court of Common Pleas. In a political publication, *The North Briton* (no. 45), he had challenged the veracity of the King's recent speech in declaring the latest peace treaty with France to be in the public's interest. Parliament's immediate response had been to imprison Wilkes for questioning the word of the monarch, an action which was subsequently declared illegal by the Court although Parliament later ordered the offending issue of *The North Briton* to be burned.

Both Freemasons and members of the Beefsteak Club, Wilkes and Hogarth had once been friends. However, Hogarth turned against his former ally. When attending the Court in order to sketch him he produced a comic, demonic portrayal which was an instant success and prompted anti-Hogarthian engravings from supporters of Wilkes.

Throughout the rumblings of the case Wilkes had fanned the fire by other deliberately provocative acts and publications. The result was a rising tide of popular support for Wilkes and for his right to free speech. Muddying his case by attracting a further charge of pornography (an obscene poem entitled *Essay on Women*), Wilkes was expelled by Parliament, and after being wounded in a duel fled to France where, now declared an outlaw, he remained for four years. Returning in 1768 (Hogarth had died in 1764), Wilkes proceeded to cause trouble by eventually finding a constituency to elect him a Member of Parliament. After he had provoked his own arrest riots ensued and there followed a farcical running battle between Parliament and the Borough of Middlesex, each refusing the other's rights of election and veto. In 1771, with the City now behind him, Wilkes was elected Sheriff of London. In 1774, after further skirmishes, he was permitted to take his seat as MP for Middlesex. He remained in parliament until 1790, support-

Fig. 91 William Hogarth, *John Wilkes*, May 1763, engraving, The Whitworth Art Gallery, Manchester
ABOVE RIGHT Fig 92. Chinese export punchbowl decorated with *Wilkes and Liberty*, *ca.* 1765, courtesy of Sotheby's, London
BELOW RIGHT Fig. 93 English delftware plate with portrait of *Wilkes*, 1760s, Royal Pavilion Art Gallery, Brighton

ing reactionary as well as radical causes.

Since he was a supporter of American patriots in the War of Independence, it is appropriate that Wilkes's portrait should figure on numerous creamware teapots (see

fig. 94, p. 108), as it was the imposition of government taxes on tea which triggered the Boston Tea Party and the American revolution.

It was presumably an anti-Wilkes customer who placed an order for a Chinese porcelain bowl featuring the Hogarth image (above), painted exactly after the print *en grisaille*. The 'Wilkes and Liberty' toast which appears on delftware plates (see fig. 93, left) dates to the City-versus-Parliament events of the 1770s, using the upper part of Hogarth's earlier (1763) portrait (see fig. 91, opposite) in which he exaggerates Wilkes's squint, also captured in the later pearlware figure (fig. 95, overleaf), where the former rabble-rouser has been transformed into the respectable statesman-like pose of a philosopher-sage. This subject also appealed to an American market where republicanism and notions of liberty remained high on the agenda, gaining further impetus with the French Revolution.

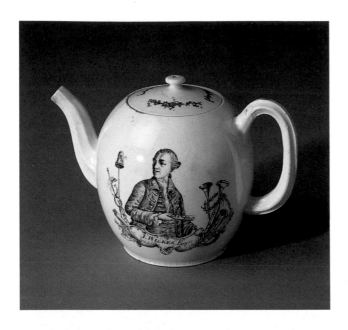

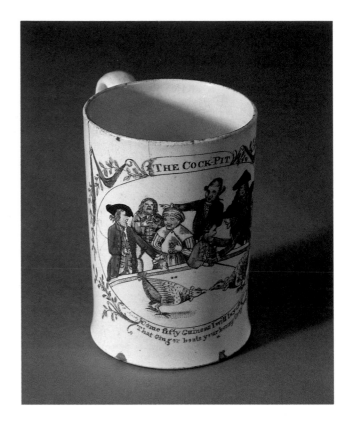

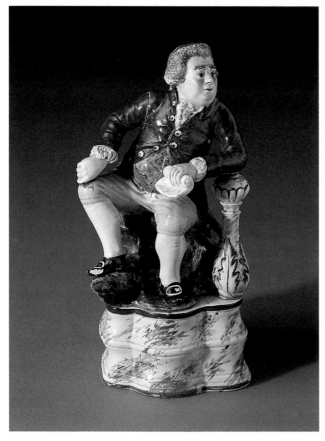

The Cock Pit

Published in 1759 – one year after the completion of the *Election* series – *A Cock Match*, or *The Cock Pit* as it has become known, is one of Hogarth's most powerful and sinister images.

At one level it simply records an everyday rowdy scene at the Royal Cockpit in Birdcage Walk, St James's Park. Cock-fighting, and bear-, bull- and badger-baiting, were a popular form of entertainment and gambling until the first quarter of the nineteenth century,[1] indulged in by lords and lackeys alike. The central Christ-like figure is a portrait of Lord Albemarle Bertie who, despite being totally blind, supervises the placing of bets and takes clear enjoyment in a match he cannot see.[2] Beneath this layer of colourful reportage, however, the animation of the image descends

FAR LEFT Fig. 94 Staffordshire creamware teapot decorated with portrait of *Wilkes*, 1760s, Royal Pavilion Art Gallery, Brighton

BELOW LEFT Fig. 95 *Wilkes*, Staffordshire pearlware figure, *ca.* 1770, Royal Pavilion Art Gallery, Brighton

LEFT Fig. 96 Staffordshire creamware mug decorated with *The Cock Pit*, *ca.* 1760, Royal Pavilion Art Gallery, Brighton

RIGHT Fig. 97 William Hogarth, *The Cock Pit*, November 1759, engraving, The Whitworth Art Gallery, Manchester

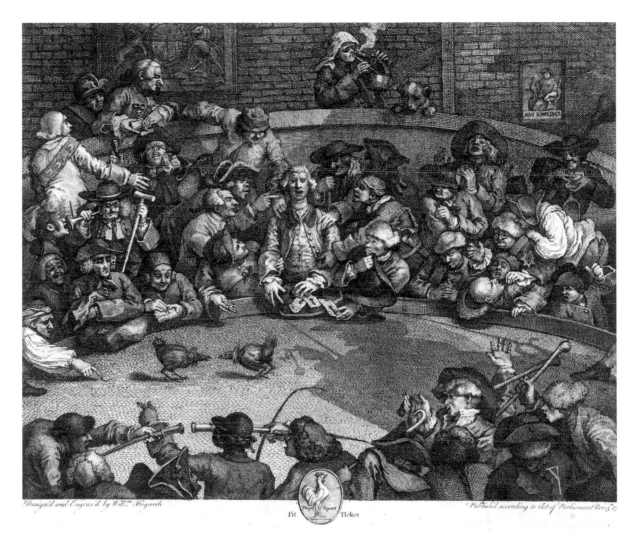

into nightmare; as Paulson points out, "[it] conveys in the actions of people trapped in futile and repetitive actions a sense of 'damnation'". Personifying the menace is the shadow cast across the pit itself. At the humorous level it merely shows us an unfortunate gambler who, unable to pay his debts, has been hoisted into the traditional basket until he can settle. Depicted by Hogarth in the pose of offering up his watch, the debtor casts a more sinister shadow, the figure of Justice – blind as the figure of Lord Albemarle Bertie – with the scales of Judgment in one hand, sword in the other.

The fact that the image was unselfconsciously adopted by Staffordshire potters (see fig. 96, opposite) shows the direct appeal at a straightforward level of a scene from everyday life. Indeed, one can imagine such jugs and mugs in use around the cock pit itself.

Business, Pleasure and Charity

Not only a robust and belligerent character, William Hogarth was also a sensitive and feeling man. His ability to create and sustain our sympathy – our interest – for his characters despite their weakness and stupidity (especially in *A Harlot*, *The Rake* and even in *Marriage à la Mode*) evinces an unmistakeable concern for his fellow creatures. Balanced alongside his lifelong involvement with the artistic life of London, Hogarth concerned himself with philanthropic and charitable works. In 1728–29 he depicted the House of Commons Committee investigating the appalling conditions of prisons; to St Bartholomew's Hospital he donated his paintings of *The Good Samaritan* and *Christ at the Pool of Bethesda*; for the London Hospital in 1740 he designed a subscription headpiece; and in 1752 he was

Fig. 98 Chinese export punchbowl, first view showing *Vauxhall Gardens*, second view showing the *Foundling Hospital*, 1730s, courtesy of Christie's, London

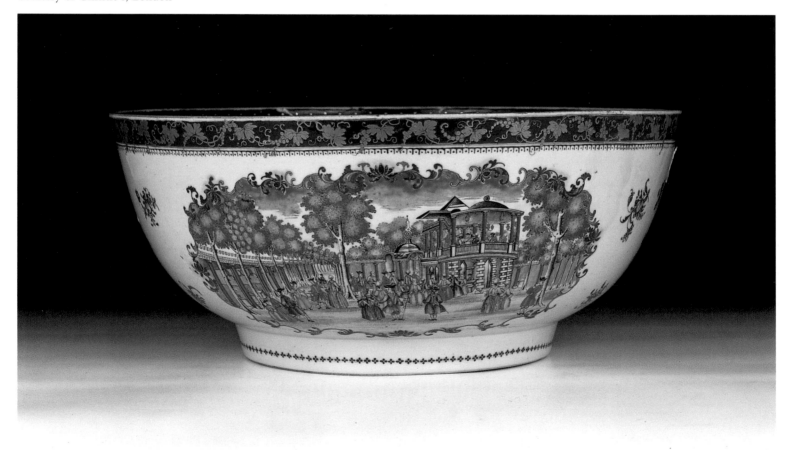

elected a governor of the Bethlehem Hospital (the very same Bedlam as depicted in *The Rake's Progress*). But of all his humanitarian interests, that of the Foundling Hospital took his major attention.

In 1739, after nineteen years of campaigning, Thomas Coram succeeded in establishing "The Hospital for the Maintenance and Education of Exposed and Deserted Young Children", the Foundling Hospital as it was known[1]. Until his intervention there had been no institution dedicated to the rescue of abandoned children in the streets of London, in contrast to the Continent where for centuries there had been refuges for unwanted or abandoned children. Among the persons named on the 1739 Foundling Hospital Charter was William Hogarth, Governor and Guardian.[2] A year later he presented the Hospital with his magnificent portrait of its founder, one of the finest English portraits of the eighteenth century, and the first great depiction of a figure from the English mercantile class. Six years later, along with the sculptor John Michael Rysbrack (1693–1770), Hogarth formed a group of artists dedicated to the furnishing and decoration of the Hospital, "to consider of what further Ornaments may be added to the Hospital without any Expence to the Charity". The artists who were prepared to offer their work free of charge included Hayman, Highmore, Hudson, Ramsay, Scott, Monamy and Wilson. Rysbrack carved a

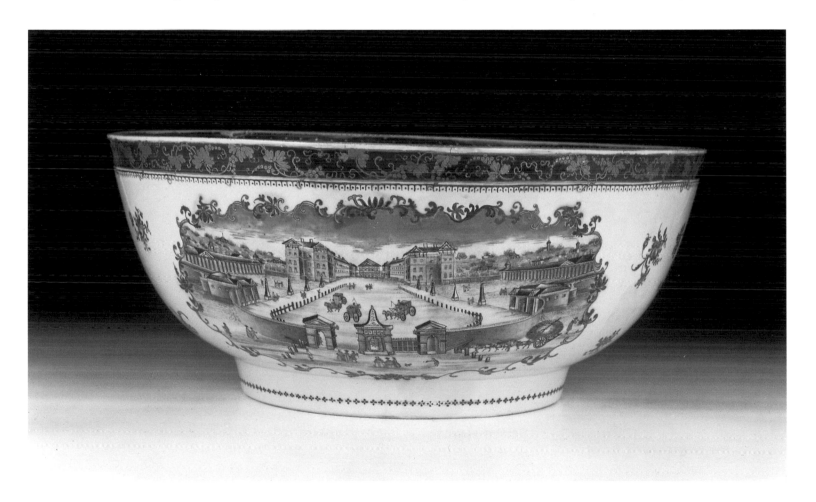

marble relief for the new Court Room while Hogarth's own contribution (in addition to the Coram portrait) was to be *Moses Brought to Pharaoh's Daughter*, a suitable subject and one already in use on the Hospital seal. Four years on, the Hospital received yet another of Hogarth's major works, *The March to Finchley,* depicting the disorderly condition of the English army *en route* to suppress the Jacobite army. The painting was spurned by George II and offered in a lottery, the winning ticket (fortuitously, of course) being that of the Foundling Hospital.[3]

As well as presenting the Hospital with its much needed decorations, the artist donors themselves benefited from the public display of their works. On the later disaffection of Hogarth and his fellow artists from the St Martin's Lane Academy, the Foundling Hospital became for a time London's primary centre for the public display of art.[4]

The Chinese exportware bowl shown on the previous page encapsulates Hogarth's involvement with pleasure and charity. United on a single piece we see depictions of two major enterprises with which he was involved – Jonathan Tyers's Vauxhall Gardens and Thomas Coram's Foundling Hospital, both of which, despite their divergent prime purposes of charity and entertainment, functioned as prominent galleries for the display of paintings of living English artists.

Though established by the mid-seventeenth century, the Vauxhall Gardens only began to become important in London social life after 1728, when the twenty-one-year-old young Jonathan Tyers took a thirty-year lease on the gardens. Ten years later, when Roubiliac's statue of Handel was installed,[5] Vauxhall had reached an all-time height of fashionability, one of its novelties being the theatrical 'letting down' of pictures specially commissioned for the supper boxes. Their installation was probably Hogarth's idea and among the paintings was his own *Times of Day* series (see figs. 52, 56 and 58, pp. 66, 70 and 72). The Gardens were a useful form of publicity for the artists, most of whom were drawn from the Slaughters Coffee-House set.[6] So popular did the Vauxhall supper-box paintings be-

come that they were issued as a series of eighteen engravings in 1743/44.

In 1746 the Foundling Hospital was relocated to its new fifty-six-acre site in a building designed by Theodore Jacobsen. Bought in 1740 from Lord Salisbury for £6500, the original four-field site was situated near Lamb's Conduit Street, close to today's Brunswick Square site.

Other ceramic images of the Vauxhall Gardens are known, including delftware examples based on prints by Edward Rooker after Antonio Caneletto. The same source was supplied for the Chinese painter of the present piece (previous page).

On 1 April 1747 the paintings created for the Foundling Hospital by Hogarth's and Rysbrack's circle were officially inaugurated. Later in the year Hogarth announced the publication of a series of twelve prints entitled *Industry and Idleness.* Based on preparatory drawings rather than paintings, the series is in effect a double progress, eight of the images depicting the advancement of the diligent apprentice, and six tracing the decline of an idle worker. At a shilling a print the series was destined not for any particular charity but for the market at large, "calculated for the use & Instruction of youth wherein every thing necessary to be known was to be made as intelligible as possible".

The Berlin porcelain bowl shown in figs. 101 and 102 carries two scenes from the series. One shows the graveyard episode where a beadle, with raised stick, discovers Tom Idle blasphemously gambling at hustle-cap upon a tomb while the industrious Goodchild attends church; the second scene depicts *The industrious 'prentice grown rich and sherriff of London.* But in this ceramic adaptation the artist has yet again had to transfer an interior scene to an *al fresco* picnic. The fact that a number of mixed Hogarth scenes have been selected for the embellishment of the bowl shows how even one hundred years later Hogarth's images were still current and available for the German porcelain designers and decorators, some of their sustained popularity having to do with the timeless themes of food and drink.

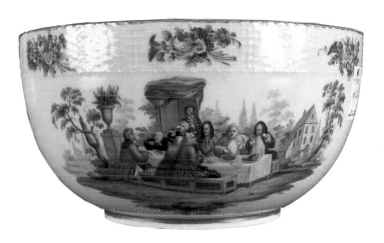

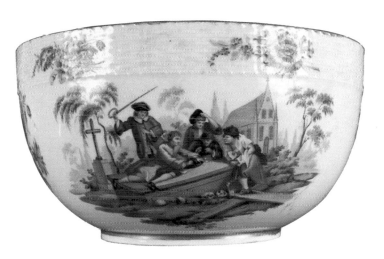

ABOVE LEFT AND RIGHT Figs. 99 and 100 William Hogarth, *Industry nd Idleness*, October 1747, engravings, The Whitworth Art Gallery, Manchester. Left, *Plate VIII: The industrious 'prentice grown rich and Sheriff of London.* Right, *Plate III: The idle 'prentice at play in the church yard, during Divine Service.*

BELOW LEFT AND RIGHT Figs. 101 and 102 Berlin porcelain punchbowl decorated with scenes from Hogarth's *Industry and Idleness* series, nineteenth-century, private collection

Epilogue: Hogarth's Dog

Of small stature, with slightly jutting jaw and a pugnacious temperament to match, it was with an engaging stroke of self-irony that Hogarth chose the pug as his lifelong canine breed and badge.[1] One of his favourite dogs, Trump, features to the fore in his own self-portrait (fig. 1, p. 16), an irreverent tongue protruding to one side.[2] At around the time of this painting, Roubiliac sculpted the terracotta bust of Hogarth (see p. 7) and, probably at the same time, his dog, Trump.[3] Both pieces were among the effects sold on the death of Hogarth's widow in April 1790. The bust is today in the National Portrait Gallery, but the original terracotta of Trump was last recorded in Wiltshire in 1832.

Nevertheless, by comparing dogs from the Chelsea porcelain factory with the dog lying at the foot of Hogarth's bust in the frontispiece of John Ireland's *Graphic Illustrations of Hogarth* (fig. 2, p. 17), it is clear that a plaster cast of Roubiliac's model must have passed to the Chelsea factory for reproduction in porcelain some time in the mid-1740s.[4] As Roubiliac was a friend of Nicholas Sprimont (silversmith and founder–owner of the Chelsea factory) it is not difficult to see how this might have occurred.

Hogarth died in 1764. His widow, Anne, continued to maintain his studio in Leicester Fields (today's Leicester Square) while residing at their house in Chiswick. For the last years of his life Hogarth had constantly championed English art against the oncoming tidal wave of Grand Tour taste for Old Masters (many of doubtful attribution). By taking up cudgels against Wilkes he had given rivals and satirists the opportunity to ridicule, in turn, an increasingly isolated artist. Sensing that his own end was near Hogarth returned to the same copper plates which had established his early fortune and independence from patronage. By reconditioning them he hoped to provide a

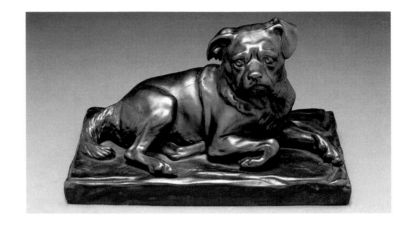

Fig. 103 *Trump*, one of a pair of Wedgwood 'black basaltes' models, *ca.* 1774, Rosalind Pretzfelder Collection, USA

future source of revenue for his wife and dependants once he was gone.

Just as Roubiliac's terracotta model of Trump had reached the Chelsea factory, where it was turned into one of the earliest and most idiosyncratic pieces of Late Baroque English porcelain, a cast of the very same model was acquired by the Wedgwood factory some time before 1774. Thereafter 'One Pug Dog' appears in the Wedgwood catalogue, with the mirrored pair added in 1777. In stark contrast to the Chelsea porcelain version, however, the Wedgwood examples were made in 'black basaltes', a lustrous black stoneware clay developed to perfection by Josiah Wedgwood in the 1760s. It was a material which, owing to its bronze-like qualities, appealed to typical Grand-Tourist mantelpiece taste and one which, along with creamware, helped to propel the ceramics industry of England (and the rest of the world) into the Neoclassical, industrial age.

Hogarth would have savoured the irony of his own dog posthumously heralding the Last Trump of a bygone era.

Glossary

armorial ware

Any *porcelain* decorated with a coat-of-arms. The *East India Company* particularly specialized in commissioning services of Chinese porcelain, each piece decorated with an armorial design sent out from Europe (see *Roast Beef* punch-bowl, fig. 87, p. 101).

basaltes/basalt

The name coined by *Josiah Wedgwood* for a deep-red *stoneware* clay which, owing to its proximity to coal-bearing seams, turns black in the firing. Often lustrous, it resembles stone or burnished bronze and was a popular material for 'Grand-Tour' interiors. Produced by many other Staffordshire factories from *ca.* 1760s onwards (see fig. 103, opposite).

blanc de Chine

Chinese *porcelain* from the province of Fujien, usually left in the white (i.e glazed but not enamelled). Wares include small tea and wine cups as well as large figures of immortals. Along with *blue-and-white* they became standard ornaments of any well appointed seventeenth- or eighteenth-century mantelpiece A number of pieces on the *Marriage à la Mode II* mantelpiece (see figs. 70 and 71, pp. 82 and 83), including perhaps the large-handed figures, seem to be *blanc de Chine* (see fig. 72, p.85).

blue-and-white

Any ceramic *ware* – usually *tin-glazed* or *porcelain* – where the design is painted in blue against a white background (e.g. fig. 33, p. 48; see also *underglaze*).

body

The name given to the actual clay material, the three basic bodies being: *earthenware*, *stoneware* and *porcelain*. Sub-groups of these include bone china, jasper, *basalt* and parian wares.

Bow

One of the first English *porcelain* factories, founded in 1744 by Thomas Frye and Edward Heylyn and situated in East London. It became the leading European producer of *blue-and-white porcelain*, coining the factory name of 'New Canton'. It went out of business in 1775 when it was probably assimilated by William Duesbury of the Derby porcelain works. Early wares include a number of figures based on well-known living actors of the Garrick and Fielding circle (e.g. fig. 84, p. 99)

brown stoneware

Developed throughout the medieval period and centered on the Rhine these *wares* range in *body* colour from white to grey. The 'brown' skin of the piece comes from iron oxide in the clay body and/or from a wash applied before the *salt-glaze* firing. The technology spread from Germany to England and, as with early *delftwares*, stonewares are difficult to distinguish from their immediate precursors. As with the pieces depicted in the earlier paintings of Breughel and other Flemmish genre artists the material was heavy, coarse and durable, lending itself to flagons, mugs and tygs for everyday domestic and tavern use. It was produced in England from the sixteenth/seventeenth century onwards. In no way aspiring to the refinement of porcelain or its imitators, the manufacture of salt-glazed brown stoneware continued into the nineteenth and twentieth centuries (e.g. Doulton,) splitting into opposite traditions: sanitary/utility wares and studio/art wares. Present in most eighteenth-century households it would have been familiar to Hogarth. A number of London stoneware makers quickly adapted his *Midnight Modern Conversation* into relief panels for mugs and flagons (see figs. 35 and 36, pp. 50 and 51).

Chelsea

One of England's first *porcelain* factories. Founded in the 1740's by Huguenot silversmith Nicholas Sprimont (see p. 6) its wares, aimed at the luxury market were superior to those of *Bow*, being creamier and more dazzling in texture. One of its earliest models is the recumbent figure of Hogarth's dog Trump, based on a model by Louis François Roubiliac (see pp. 114). The factory is linked to other London porcelain concerns, including the 'Girl-in-a-Swing' group. The clay *body* and *glaze* vary considerably over its period of production. Its forms are derived from the *Meissen* factories as well as the white wares of Fujien (see *blanc de Chine*). The factory and its models and casts was eventually taken over in 1769 by William Duesbury of the Derby porcelain works.

china

A popular umbrella term formerly encompassing anything white or *blue-and-white* (porcelain or tin-glazed earthenware) but today embracing only porcelain, that is, anything made out of *hard* or *soft-paste* porcelain (including bone china, a late eighteenth-century ceramic body, its invention accredited to Josiah Spode).

creamware

Developed in Staffordshire by 1743, emerging out of white *stoneware*. The medium of many Staffordshire potters, including Thomas Whieldon and *Josiah Wedgwood* (see *Queen's ware*), as well as in Yorkshire (Leeds ware) and Liverpool (see fig. 94, p. 108).

Derby

One of the first English porcelain factories, founded by Andrew Planché around the year 1745; active to this day though with a hiatus and a shift in ownership in the mid nineteenth century As well as its own unique creations, the factory also copied its London rivals, acquiring the *Chelsea* and possibly the *Bow* businesses later in the 1770's.

earthenware

One of the three basic ceramic bodies: a porous clay fired to a temperature of 300-1000°C, requiring a *glaze* to render it waterproof (*delftware*, *slipware* and *creamware* are all earthenwares) (see fig. 29, p. 44; see also *body*).

East India Company

Several European States created compa-nies with exclusive trading rights to the Far East. The first Europeans to trade in quantity with China were the Portuguese (from the sixteenth century) followed by the Dutch. England's own East India Companies conducted trade through the seventeenth century, strengthening their position from 1708 with the merger into a single United East India Company trading to the port of Canton. Though the original goals had been tea, spices and silk, the porcelain trade, conducted by individuals using the East India Company as a facility, soon became an important part of the trade. With an estimated 100 million pieces of Chinese porcelain reaching England throughout the eighteenth century, the effect on England's native ceramic industry was incalculable. The trade supplied not only tea wares but a whole range of domestic 'luxury' wares (lacquer, metal-work, pictures, textiles, furniture, etc.) for an ever wealthier class competing for exotic rather than home-made goods. The majority of pieces on the mantelpiece of *Marriage à la Mode II* personify this trade and Hogarth's critical response (see fig. 70, p. 82 and front cover).

enamels

Coloured glass or glaze-like pigments used in the *on-glaze* painting (i.e. requiring a separate firing) of polychrome decoration on *porcelain* and on *salt-glazed white stoneware* (see fig. 68, p. 80; also *famille-verte* and *famille-rose*).

Export porcelain

see *East India Company*.

famille-rose

A Chinese porcelain colour scheme of mainly opaque *enamels* including a new pink colour (giving the palette its name), introduced by Europeans to Chinese porcelain decorators around 1720, and soon supplanting the earlier *famille-verte* style.

famille-verte

A Chinese porcelain colour palette of mainly transparent *enamels* including two greens, yellow, blue, aubergine, iron-red and black. Though developed much

earlier, it is mainly identified with the late seventeenth/early eighteenth centuries (the Kangxi reign period, 1662–1722).
(see *famille-rose*)

glaze
A glassy film used to cover any ceramic body. Different recipes are used for different effects and wares.
(see *tin-glaze, lead-glaze, salt-glaze*)

grisaille
Decoration in monochrome grey
(see *Wilkes* bowl, fig. 92, p. 107).

hard-paste
A *porcelain body* made to the same basic recipe as Chinese porcelain.

Imari
A *porcelain* colour palette containing the three basic colours of blue (*underglaze*), iron-red and gilding, often with other enamel colours added. Named after the Japanese port through which from the seventeenth century onwards many wares of this type were shipped To Europe.

Kakiemon
The name given to a Japanese *porcelain* colour-palette style comprising coloured enamels of turquoise blue, *underglaze*-blue, yellow, iron-red, black (or a permutation of these). Named after the potting family traditionally associated with its manufacture from the seventeenth century onwards, though known to have been produced at several sites. Very popular in Europe in the seventeenth/early eighteenth centuries (see front cover and p. 82,) it stimulated a number of designs among the early European porcelain factories, notably at *Meissen*.

lead-glaze
The most common *glaze* covering for *eartheware bodies* in Europe up until the late nineteenth century (see *creamware, slipware*). Even *tin-glazed earthenwares* use a lead-glaze as a basic medium for the opaque *glaze*.

Longton Hall
One of England's first porcelain factories, situated at the heart of Staffordshire in one of the towns making up today's Stoke-on-Trent. Active from 1750 to 1760 when its creator, William Littler removed to re-establish his porcelain works at West Pans in Scotland. (see fig. 66, p. 79).

Meissen
The first European *hard-paste porcelain* manufacturer. Owned by Augustus the Strong, King of Poland and Elector of Saxony, it was maintained and catered purely for courtly patrons. The first porcelains were produced around 1710 and within a very short period the Meissen factory was to produce porcelain figures of a quality never surpassed in the following two hundred to two hundred and fifty years. Disaffecting workmen soon diffused the jealously guarded manufacturing secrets, causing a spate of provincial porcelain manufacturers throughout Europe up until the 1760s, most maintained by princely patrons. Itself drawing on Japanese *Imari* and *Kakiemon* patterns and forms, the Meissen factory in turn became a major inspiration for the later English porcelain makers of the mid eighteenth century (*e.g.* figs. 37 and 50, pp. 51 and 65).

pearlware
The successor to *creamware*, this a white *earthenware body* covered in a *lead-glaze*, tinted blue with a touch of cobalt. In all other respects like creamware. Produced from *ca.* 1770 and into the nineteenth century (see *Wilkes*, fig. 95, p. 108).

porcelain
A ceramic *body* fired to a temperature where, as with *stoneware*, the individual grains of clay fuse to form a vitreous body, but having the additional properties of whiteness and transparency (when sufficiently thinly potted). The first porcelains were evolved in China through the Tang (AD 618–906) and Song (AD 960–1279) dynasties, creating a formula of two basic ingredients, china clay (kaolin) and china stone (petuntse); this resulted in a *hard-paste* or 'true' porcelain. Several early attempts to

produce a similar material in Europe brought partial success: the Medici family in Florence in the late 1500s and the French, one hundred years later, producing 'artificial' or *soft-paste* bodies of a very different quality. The first European success with hard-paste came in *ca.* 1710 with the *Meissen* factory whose modelling and general style came to dominate the subsequent porcelain factories, notably their creation of figures, replacing earlier marzipan table ornaments. A separate soft-paste tradition continued in France, most notably with Chantilly, Mennecy, St. Cloud, Vincennes and Sèvres; when they finally emerged in the 1740s it was to this tradition the English porcelain factories belonged.

Queen's ware
Josiah Wedgwood's own term for *creamware*, coined in 1766 once Queen Charlotte had accepted his own creamware service thereby giving him a 'by appointment' marketing advantage over Staffordshire and Yorkshire competitors. (see fig. 9, p.22)

red stoneware
A vitrified (non-porous) fine-grained red *body* produced at various times throughout the world, notably at *Yixing* (China), in Staffordshire (from the late seventeenth century), in Holland and at *Meissen* (*ca.* 1710) where, as elsewhere, the secrets of its manufacture were thought to be linked to *porcelain*. Arriving in Europe along with tea in the mid seventeenth century, Yixing stoneware could supply most of the major pieces for a tea equipage: teapot, caddy, teabowls and saucers, though in pictures of the period it appears to be mixed with silver and porcelain (see fig. 11, p. 24).

salt-glaze
A colourless *glaze* formed by throwing common salt into a *stoneware* firing, causing the salt to vaporize and stick to all directly exposed surfaces. Used on both white and brown *stonewares* it forms a characteristic 'orange-peel' texture (*e.g.* fig. 36, p. 51).

slipware
A *lead-glazed earthenware* decorated in a variety of coloured 'slips', that is liquid clays applied by immersion or tubing and decorated with further colours or cut away in *sgrafiatto* (incised) technique: produced at a number of centres including some famous examples from South Staffordshire where the finest wares were made by a small number of families operating between the late seventeenth and mid eighteenth centuries. (see fig. 53, p. 67)

soft-paste
A *porcelain body* not made to the Chinese recipe. So-called because of the apparent softness of material when compared to *hard-paste* 'true' porcelain from China or Germany.

stoneware
A hard ceramic *body* in which the grains of the clay body fuse to form a nonporous material. Unlike *earthenware*, therefore, no *glaze* is required to render the material watertight.

tin-glaze
A *glaze* to which ashes of tin have been added, rendering it opaque when fired and allowing various colours to be painted without their being lost against the darker *body* colour (still visible under a transparent glaze). Depending on its country of manufacture tin-glazed *earthenware* is given different names: in Spain and Italy *maiolica*, in France and Germany *fayence/faïence*, in Holland and England *delft/delftware* (though the old English term was *gallipots/galliware*). British delftware was derived from the Dutch tradition, the first pieces being made some time in the second half of the sixtennth century. Throughout the seventeenth and into the second half of the eighteenth century the industry prospered with many factories in the great port cities of Bristol, Liverpool, Dublin, Glasgow and London. Delftware at first competed successfully with Chinese *blue-and-white* but came under increasing pressure with ever greater quantities of cheaper *porcelain* imported by the *East India Company*. A major blow came with the creation in

the 1740s/1750s of new English porcelain factories, shortly followed by the *Wedgwood* revolution of *creamware* and *pearlware* in the 1770s/1780s. Bar a few apothecary-ware producers, by the end of the eighteenth century the British delftware industry had died.

Painted in the 1740s–1760s at the height of the industry (and at the peak of punch-drinking) a number of delftware punchbowls carry versions of Hogarth's *A Midnight Modern Conversation* (see fig. 38, p. 52). The blue dragon bowl in the Thomas Coram Foundation is traditionally associated with Hogarth (see fig. 34, p. 49), while a set of Dutch delft plates (now in the British Museum) painted with signs of the zodiac bears the signature of Hogarth's father-in-law, Sir James Thornhill (see fig. 4, p. 18).

transfer-printing
The process by which a copper engraving is printed onto paper and then transferred to a ceramic surface as on-glaze or *underglaze* decoration. Its development at *Worcester* (see page 39) and in the earthenware industries revolutionized British ceramics, especially in the *creamware* tradition, allowing mass-production of customised or commemor-ative wares for domestic and foreign markets (see Wilkes, figs. 92–94, pp. 107–08). Other forms of transfer-printing were also developed later in the century.

underglaze
A term denoting a pigment, typically blue (cobalt oxide) painted or printed on to a ceramic body prior to covering it in a glaze and firing it. The process permits a single firing, and is therefore cheaper than polychrome wares with their multiple firings. Chinese *blue-and-white porcelain* (traditionally dubbed 'Nanking' ware) provided the primary impulse and source for most European porcelain factories decorating in underglaze-blue.

Vauxhall
One of the early London porcelain factories, founded *ca.* 1751 and active until *ca.* 1764. Just as the Chelsea works were placed near the Ranelagh Gardens, the

Vauxhall porcelain works were close to the Vauxhall Gardens at whose clientelle this new material was partially aimed

ware
1) the physical clay material (*body*), or
2) a specific name given to a particular ceramic tradition, e.g. *delftware*, *creamware*, *pearlware*, jasperware, *basalt* ware, etc.

Wedgwood, Josiah
Though not its inventor, Josiah Wedgwood (1730-1795) transformed the local development of *creamware* into a major step in England's ceramic and Industrial Revolution. By bringing his processes to technical perfection he was able to manufacture quantities of quality-controlled table and ornamental wares. Marketing them to the Royal Family (as *Queen's ware*), he created a fashionable demand among the wealthy upper classes for a native ware which at long last challenged Chinese supremacy. Wedgwood's success allowed him to perfect other ceramic bodies – including jasperware and black *basalt* – which perfectly reflected the growing new taste for Grand Tour classicism. In this he catered for the opposite of all Hogarth's rococo values.

white stoneware
Or 'fine white stoneware'. A chalky white ceramic *body* of white to grey colour, developed in Staffordshire throughout the 1730s and 1740s and glazed with vaporized salt (see *salt-glaze*) giving an 'orange-peel' texture. Flatwares are often moulded with trellis designs, sometimes left in the white and sometimes enamelled in colours. Some pieces are slip-cast and almost paper-thin. Though not translucent, the material superficially resembled Chinese porcelain and dealt an initial blow to it as well as the hitherto predominant native *delftware* tradition. Most importantly, as a fully refined white clay *body* it formed the technical basis for the revolutionary *creamware* tradition and the subsequent legacy of *Josiah Wedgwood*.

Worcester
The Worcester porcelain factory was

established in 1752, assimilating Benjamin Lund's two-year-old Bristol porcelain factory. Since then there has been almost continuous production, with shifts in partnerships and mergers in the late nineteenth century. Producing *blue-and-white* as well as *enamelled* (polychrome) decoration, its main inspirations were Chinese and Japanese wares, *delftware* patterns and silver forms as well as those from *Meissen*. Perhaps its greatest eighteenth-century innovation was the use of *transfer-printing* (see fig. 23, p. 39).

Yixing stoneware
see *red stoneware*

Notes

INTRODUCTION

1 It should be owned, however, that in many paintings it is difficult to decide upon a continent, let alone country, of origin, a problem which increases where only a print survives.

2 Dickens, with his mastery of visual description, was deeply influenced by the works of William Hogarth. Together, both men have given us a physical and psychological portrait of London, spanning one hundred and fifty years. Their early experiences of hard times played a major factor in their desire to portray the rawness of life while also spurring them to avoid it. When still in their early teens their fathers were both declared insolvent and were committed to debtor's prison: Richard Hogarth to the confines of the Fleet for four years (*ca.* 1708–12, William being then between eleven and fifteen years old), and John Dickens for fourteen weeks in the Marshalsea (in 1824, Charles being twelve years old). By curious coincidence, in 1836 Dickens married Catherine, daughter of George Hogarth, editor of the *Evening Chronicle*, for whom the young Dickens penned his 'London Sketches' (see Ackroyd, p. 162f.). What relationship, if any, there was between the two Hogarth families the author has not discovered.

3 *E.g. The Rake's Progress* (1736), see p. 58.

4 The final scene of *The Dunciad* (1728), 'The Triumph of Dullness', must have been at the back of Hogarth's mind when engraving his last, valedictory print, *The Bathos* (see p. 9).

6 This composition is Hogarth's 'Line of Beauty', expounded and developed in his major theoretical treatise *An Analysis of Beauty*.

HOGARTH'S CHINA

1 Hogarth must have felt a little tug of irony when creating his 1747 series *Industry and Idleness*: the series exhorts apprentices to work hard for future rewards when Hogarth himself had abandoned his own apprenticeship in the silver-engraving business.

2 See front cover illustration and pp. 71–72.

3 It is interesting to note that members of the Strode family (fig. 19, p. 33) were among the sitters painted by Thomas Frye, founder of the Bow factory.

4 See Hogarth's *Analysis of Beauty*.

5 See Mallett 1967, p. 7.

6 Quoted in Ellmann 1987, pp. 43–44.

COFFEE, TEA AND CHOCOLATE

1 Emmerson 1992, p. 1; also known as 'Garway'. His proved to be one of the most enduring coffee-houses, featuring in Dickens's works and continuing into the 1860s.

2 Latham and Matthews 1983, X (Companion), p. 70f..

3 *Ibidem*.

4 Tate Gallery, London, inv. no. 4500; Einberg and Egerton 1988, no. 159.

5 Paulson 1992, I, p. 41.

6 *Ibidem*, p. 52.

7 See Dabydeen 1985.

8 Another teapot with a wood replacement handle and possibly silver spout can be seen in another of Hogarth's tea pieces of about the same period, *The Western Family* (National Gallery of Ireland).

A HARLOT'S PROGRESS

1 Paulson 1992, I, p. 238f.: sparked by Steele's article in *The Spectator*, no. 266, Hogarth started with *A Harlot's Progress III*, pulling together a number of current scandals, one involving Colonel Charteris condemned on a charge of rape (but saved from hanging by his influential relatives), another involving a highwayman by the name of Hackabout; another episode in which Sir John Gonson's campaign to purge London of vice brought a certain Katherine Hackabout, sister of the condemned highwayman, to Bridewell Prison (where as in *Harlot IV* she would be forced to beat hemp).

2 According to Nichols, *General Works* 1:43–44, quoted by Paulson 1993, I, p. 199.

3 *Ibidem*, p. 372, note 3.

4 See *Engraving of Hancock* 1991, nos. 15, 15a and 16.

5 Hubert François Gravelot and Henry Fielding had responded in verse and obscene prints to the *cause célèbre* of a Jesuit priest and a harlot which, according to Paulson 1992, would have been fresh in Hogarth's mind at the time he was creating the series.

6 Menzhausen 1993, pp. 194–97.

7 The same issue arises in *The Rake's Progress VI* (see fig. 47, p. 62).

8 Paulson 1992, I, p. 247.

A MIDNIGHT MODERN CONVERSATION

1 A very strong peak in recorded pieces dated 1745 may reflect a high tide of patriotic toasting at the climax of the Hanover–Stuart divide.

2 When placing an order with a representative of the East India Company for armorial services, it was customary for the client to submit a printed Ex Libris bookplate bearing his arms. It could either be coloured directly or the fields labelled with their proper tinctures.

3 The original painting, which is today in the Yale Center for Art, Paul Mellon Collection, is longer and narrower (78.7 cm × 162.6 cm) but shows the same eleven gentlemen in the same attitudes.

4 The cleric with the ladle has been identified as Cornelius Ford, cousin of Samuel Johnson; above him, with glass raised in song, is the tobacconist John Harrison; Kettleby (a barrister), Chandler (a bookbinder) and on the floor James Figg, a prize-fighter who also appears in several of Hogarth's later works (*e.g.* the fencing master in *Rake II*).

5 In his advertisement Hogarth announces: "a large Copper Plate from a Picture of his own painting representing a Midnight Modern Conversation, consisting of ten [sic] different Characters" (Paulson 1992, II, p. 5).

6 The attribution to Hogarth is traditional. At the time of writing the author was unaware of documentary evidence. Likewise a group of memorabilia traditionally associated with Hogarth was bequeathed to Aberdeen by the descendant of a nineteenth-century namesake of William Hogarth (apparently unrelated): this group also contains a punchbowl.

7 A grinning stoneware bellarmine bottle labelled 'NANTS' stands on the floor in the final scene of *A Harlot's Progress*; in the earlier scene of the harlot in her chamber, her bunter may be using a stoneware mug to replenish the porcelain teapot, though the piece may equally be a pewter tankard. The jug in the bottom right of *An Election* (fig. 88, p. 103) appears to be lead-glazed earthenware rather than stoneware.

8 Certainly the idea of sending up an Old Master came naturally to Hogarth. The perverse translation of a sober medical dissection to the intemperate dissection of a punchbowl is entirely in keeping with Hogarth's and other literary figures' mock-heroic excursions.

9 Compare a very similar bowl in Norway carrying the *Midnight Modern Conversation* on one side and a Danish East Indiaman on the other – a special commission for Captain Mørch of Kristiansand (see Johanne Huitfeldt, *Ostindisk porselen i Norge*, 1993, p. 72: information David Howard).

THE RAKE'S PROGRESS

1 Paulson 1992, II, p. 20 quotes an extract from Mary Davy's *The Accomplish'd Rake* (1727) where the hero, Sir John Galliard, comes to London: "The first progress he made in the modern

gallantry was to get into the unimproved conversation of the women of the town, who often took care to drink him up to a pitch of stupidity, the better to qualify him for having his pockets picked."

2 'Lady' is perhaps not quite right: the woman is undressing in order to entertain the company with a popular if obscene entertainment, described by Jean André Rouquet, a contemporary Hogarth commentator and near neighbour, "*Ce grand plat va servir à cette femme comme à une poularde; elle s'y placera sur le dos; et l'ivresse et l'esprit de débauche feront trouver plaisant un jeu, qui de sang-froid ne le paroît guère ... Il suffit de vous laisser à deviner la destination de la chandelle*" (quoted in Quennell 1955, p. 131)

3 ... and not for the first time: depictions of Scottish Highlanders with bagpipes proved a major challenge to the Chinese porcelain painters.

4 In her book on the Pauls-Eisenbeiss Collection, *In Porzellan verzaubert*, Dr Ingelore Menzhausen illustrates two versions of the group, one with a bird cage, the other with a coffee table. Dr Menzhausen states that this group and its variants were inspired by the Rose Tavern scene from *The Rake's Progress* (p. 92f.).

BEFORE AND AFTER

1 Menzhausen 1993, pp. 64 and 150f..

THE FOUR TIMES OF DAY

1 Illustrated in *Rococo: Art and Design in Hogarth's England* 1984.

2 See Christie's, London, Rous Lench sale, 29 May 1990, lot 79.

3 Fidelle Duvivier (1740–?1817), itinerant Belgian ceramic decorator who may have worked for Nicholas Sprimont at Chelsea.

4 Two other Hogarth images also seem to be echoed in models attributed to the influential Wood family of Staffordshire, see *Hudibras* (figs. 63 and 64, pp. 76–77) and *The Sleeping Congregation* (figs. 61 and 62, pp. 74–75).

5 Among the factories which produced the model are Turners (in white stoneware, *ca.* 1830, remodelled probably by William Massey; see Bevis Hillier, *The Turners of Lane End* (London 1965) p. 24 and fig. 19b) and Adams (illustrated by William Turner *The Collector I* (1907) p. 46).

THE ENRAGED MUSICIAN

1 See fig. 21, p. 35.

2 See Cyril Cook, the *Life and Work of Robert Hancock*, London 1948.

3 On a Chinese porcelain saucer in the Victoria and Albert Museum we see a young milkmaid approaching a stile, possibly related to one of the other three Hancock 'Milkmaid' prints.

4 See Sotheby's catalogue, New York, 15.10.96, lot 135.

MARRIAGE A LA MODE

1 "One God, One Farinelli" was the rapturous cry elicited by the Italian on coming to Covent Garden.

2 In extreme cases, aristocratic collectors converted whole rooms to a series of shelves and alcoves allowing porcelain to be hung and stacked as wall-paper.

3 Dr Misaubin, St Martin's Lane.

TASTE IN HIGH LIFE

1 Monkey groups – or *singeries* – had become popular throughout Europe, not least in porcelain, the most celebrated example being J.J. Kändler's *Affen Theater*, a band of monkeys in court costume all playing different instruments, also executed in the 1740s.

2 They were so popular, in fact, that Hogarth was prompted to engrave a second edition in 1744.

HOGARTH, GARRICK AND THE DRURY LANE THEATRE

1 The two combined in *Southwark Fair* (see fig. 41, p. 56).

2 For a full and fascinating book on the

mid-eighteenth-century stage in which many of Hogarth's friends and acquaintances appear, linked to the Bow porcelain factory which itself derived so much inspiration from Garrick, Quin and their circle, see Raymond Yarbrough 1996.

3 At Goodman's Fields Theatre.

4 See Raymond Yarbrough 1996.

5 With the passing of the rôle to Garrick's successors, the Derby factory continued to produce the 'Garrick' model, though with remodelled heads to follow the features of Kemble and then of Kean.

6 See *Rococo, Art & Design in Hogarth's England* 1984, p. 67f. (E7).

7 See Yarbrough 1996, p. 37.

8 Garrick sought help from his old teacher Samuel Johnson whose own quatrain testifies an even greater admirer:

The Hand of Art here torpid lies That traced the essential form of Grace; Here Death has closed the curious eyes That saw the manners in the face

(quoted by Quennell 1955, p. 296).

9 An apparent idiosyncrasy of Quin's style, captured also in Hogarth's 1739 portrait (illustrated in Einberg and Egerton 1988).

10 See Yarbrough 1996, who reiterates the case for their positive attribution.

THE GATE OF CALAIS

1 In this Fielding was well placed: his earlier years in London were somewhat rakish after which he turned to law and sat as magistrate.

2 For a fuller account of the episode with references to the many original sources, see Einberg and Egerton 1988, p. 127f.

3 See Howard and Ayers, *China for the West* (London 1978), II, p. 422, no. 423.

AN ELECTION

1 Paulson 1993, III, p. 471, note 14.

THE COCK PIT

1 In addition to the clear compositional reference to *The Last Supper*, the *Cock Pit* has also been related to Dante's *Inferno*, recently translated by Hogarth's friend William Huggins whose invitation to illustrate the work Hogarth declined on account of the enormity of the project.

2 See *Circus & Sport* 1990, p. 51.

BUSINESS, PLEASURE AND CHARITY

1 The charity continues to this day as the Thomas Coram Foundation, based in Brunswick Square, London.

2 The list of governors reads like an artist's *Who's Who* in eighteenth-century London.

3 All the cited Hogarth's works as well as many of the others are still to be found at The Thomas Coram Foundation, Brunswick Square.

4 See Paulson 1993, III, p. 302f.

5 Handel was a co-governor of the Foundling Hospital along with William Hogarth.

6 Hayman, Gravelot, Yeo and Moser (the latter was also involved with the later Foundling Hospital).

EPILOGUE

1 He is known to have had at least three: Pugg, Trump and Crab (see Paulson 1965)

2 Vertue records a bust of Hogarth in Roubiliac's studio in 1741.

Select Bibliography

Peter Ackroyd, *Dickens*, London (Sinclair-Stevenson) 1990

Michael Archer, *Delftware*, London (V&A and HMSO) 1997

R.B. Beckett, *Hogarth*, London (R&KP) 1949

David Bindman, *Hogarth*, London (Thames & Hudson) 1981

Joseph Burke and Colin Caldwell, *Hogarth: The Complete Engravings*, London (Thames & Hudson) 1968

Circus & Sport, exhib. cat. by Patricia Halfpenny and Stella Beddoe, Louisville, Kentucky, J.B. Speed Art Museum, 1990

A Collection of Early English Pottery, exhib. cat. by Jonathan Horne, London, Jonathan Horne, 1981

Come Drink the Bowl Dry, exhib. cat. by Peter Brown and Maria H. Schwartz, York, Fairfax House, 1996

John Cushion and Margaret Cushion, *A Collector's History of British Porcelain*, Suffolk (Antique Collectors' Club) 1992

David Dabydeen, *Hogarth's Blacks*, Mundelstrup, Denmark 1985

David Drakard, *Printed English Pottery*, London (Jonathan Horne) 1992

Elizabeth Einberg and Judy Egerton, *The Age of Hogarth*, London (Tate Gallery) 1988

Richard Ellmann, *Oscar Wilde*, London (Hamish Hamilton) 1987

Robin Emmerson, *British Teapots and Tea Drinking*, London (HMSO) 1992

The Engraving of Robert Hancock, exhib. cat. by Anne M. George, London, Albert Amor, 1991

An Exhibition of English Pottery, exhib. cat. by Garry Atkins, London, Garry Atkins, 1993

Anton Gabszewicz with Geoffrey Freeman, *Bow Porcelain*, London (Lund Humphries) 1982

Lincoln Hallinan, *British Commemoratives*, Suffolk (Antique Collectors' Club) 1995

Bevis Hillier, 'Nicholas Crisp and the Elizabeth Canning Scandal', *English Ceramics Circle Transactions*, vol. 16, pt. 1 (1996), pp. 7–51

In Praise of Hot Liquors, exhib. cat. by Peter Brown, York, Fairfax House, 1995

Edd. R.C. Latham and W. Matthews, *The Diary of Samuel Pepys*, London (Bell) 1983

Jack Lindsay, *Hogarth, his Art and his World*, London (Granada) 1977

Roger Lonsdale, *Dr Charles Burney*, Oxford (Clarendon) 1965

Neil McWilliam, *Hogarth*, London (Studio) 1993

J.V.G. Mallett, *Hogarth's Pug in Porcelain*, London (V&A Museum Bulletin Reprints 1971, no. 16) 1967

Ingelore Menzhausen, *In Porzellan verzäubert*, Basel (Wiese Verlag) 1993

Ronald Paulson, *Hogarth*, 3 vols., I: *The Modern Moral Subject*, Cambridge (Lutterworth) 1992; II: *High Art and Low*, Cambridge (Lutterworth) 1992; III: *Art and Politics*, Cambridge (Lutterworth) 1993

Porcelain for Palaces, exhib. cat. by John Ayers, Oliver Impey and J.V.G. Mallett, London, Oriental Ceramics Society, 1990

Peter Quennell, *Hogarth's Progress*, London (Collins) 1955

Rococo: Art and Design in Hogarth's England, exhib. cat., edd. Michael Snodin *et al.*, London, V&A, 1984

Christina Scull, *The Soane Hogarths*, London (John Soane Museum) 1991

A Tale of Three Cities, exhib. cat. by David S. Howard, London, Sotheby's, 1997

The Wrestling Boys, exhib. cat. by Gordon Lang, Stamford, Burghley House, 1983

Raymond C. Yarbrough, *Bow Porcelain and the London Theatre*, Michigan (Front and Centre) 1996